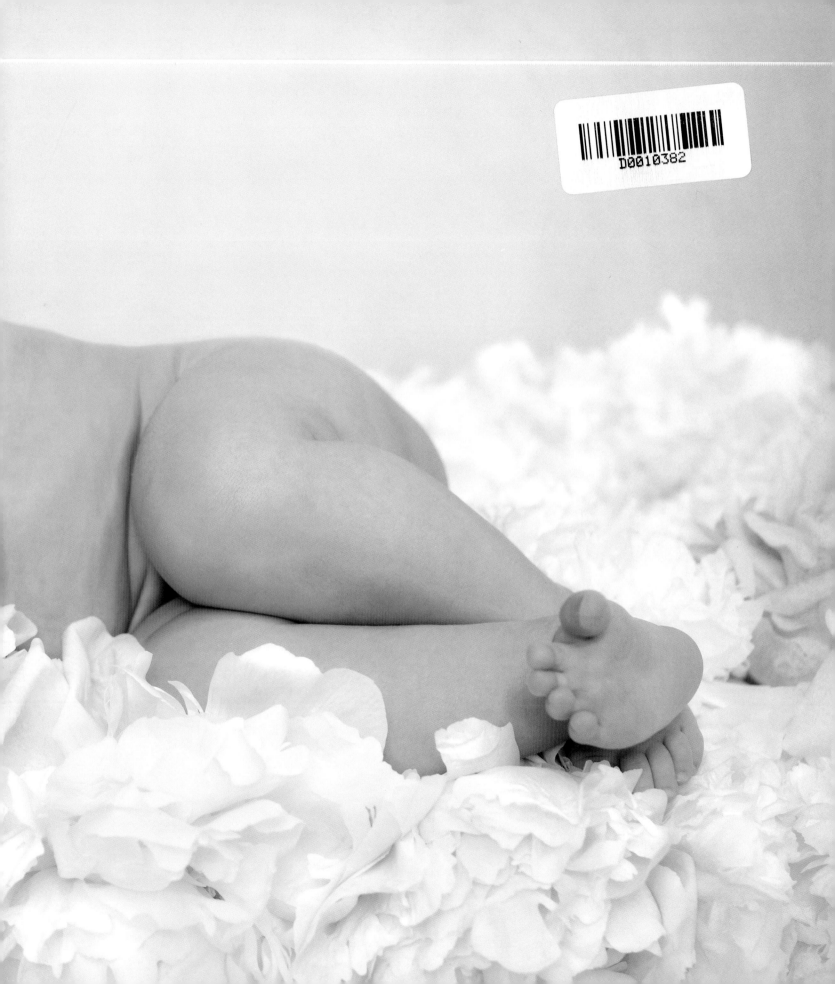

BABY LOVE

An Affectionate Miscellany

**Andrews McMeel
Publishing, LLC**

Kansas City

in association with PQ Blackwell

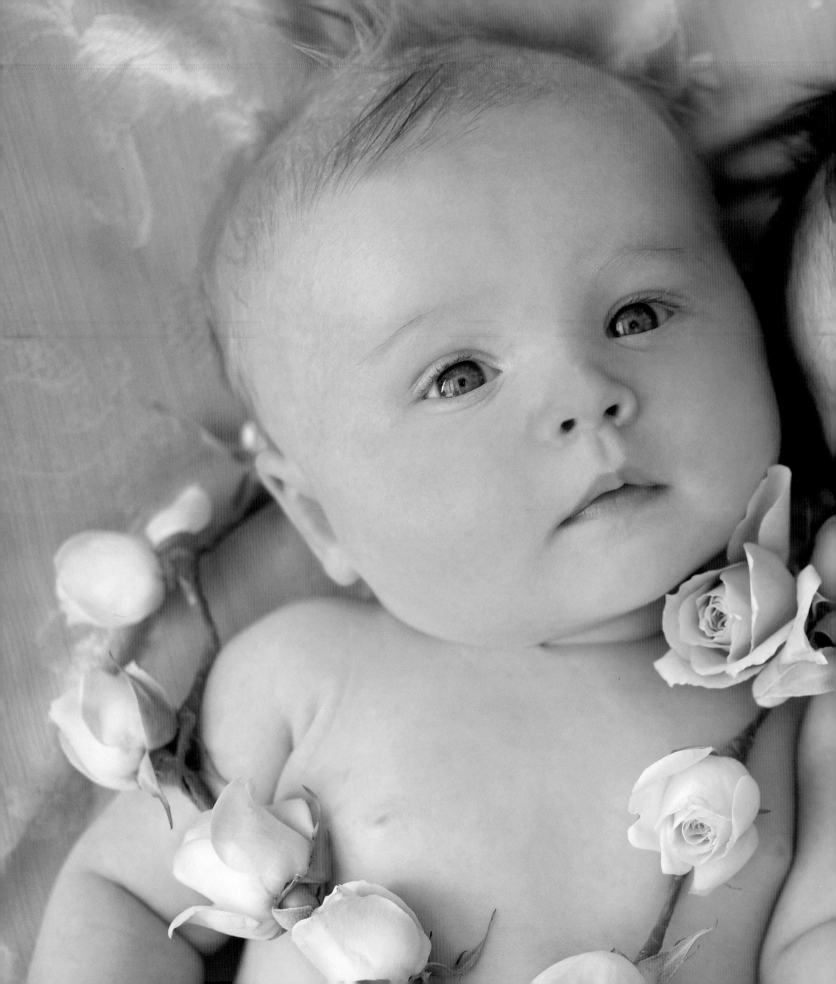

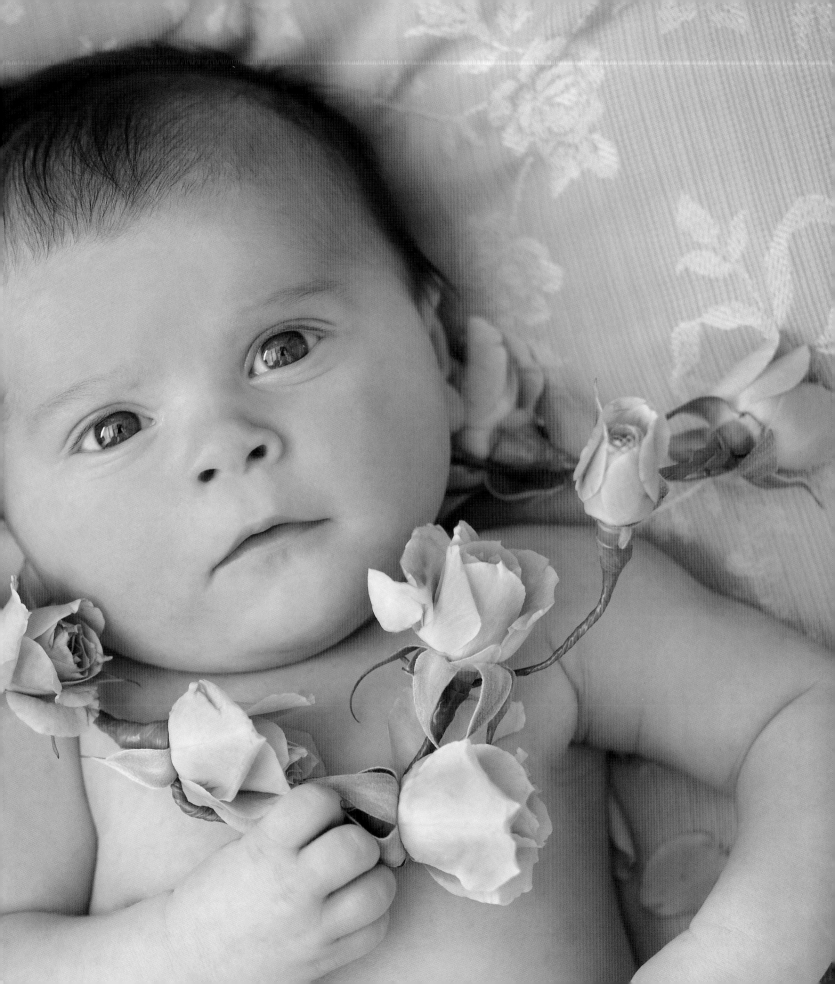

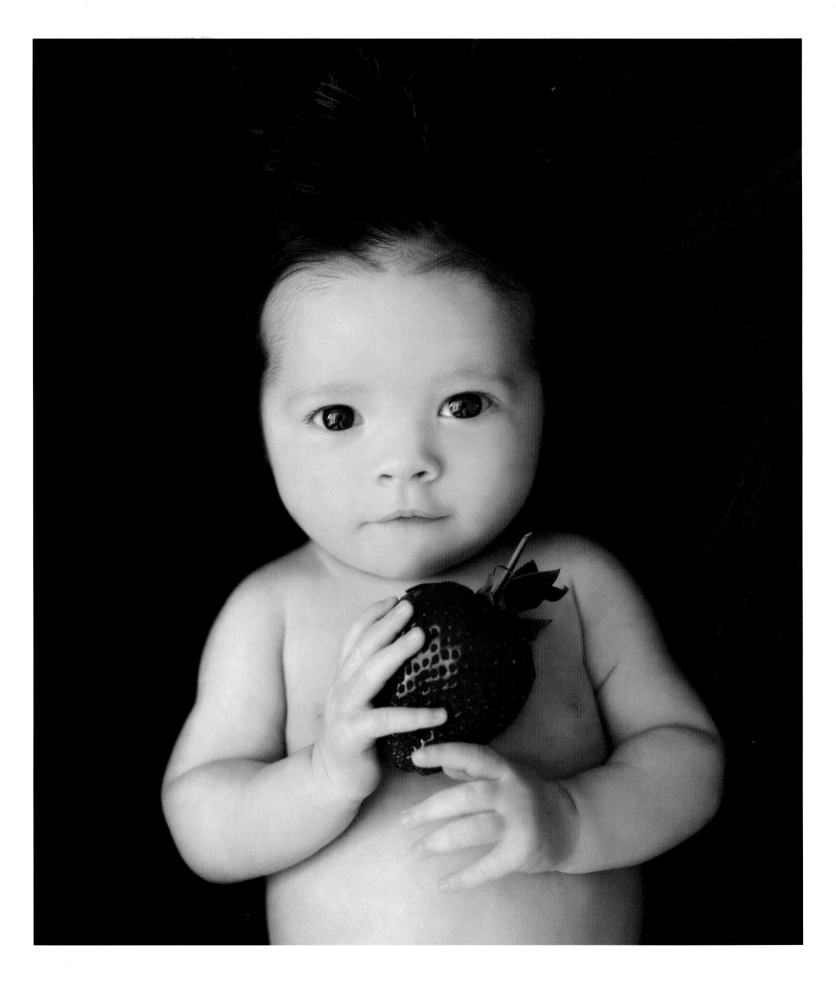

Every child begins the world again.

HENRY DAVID THOREAU

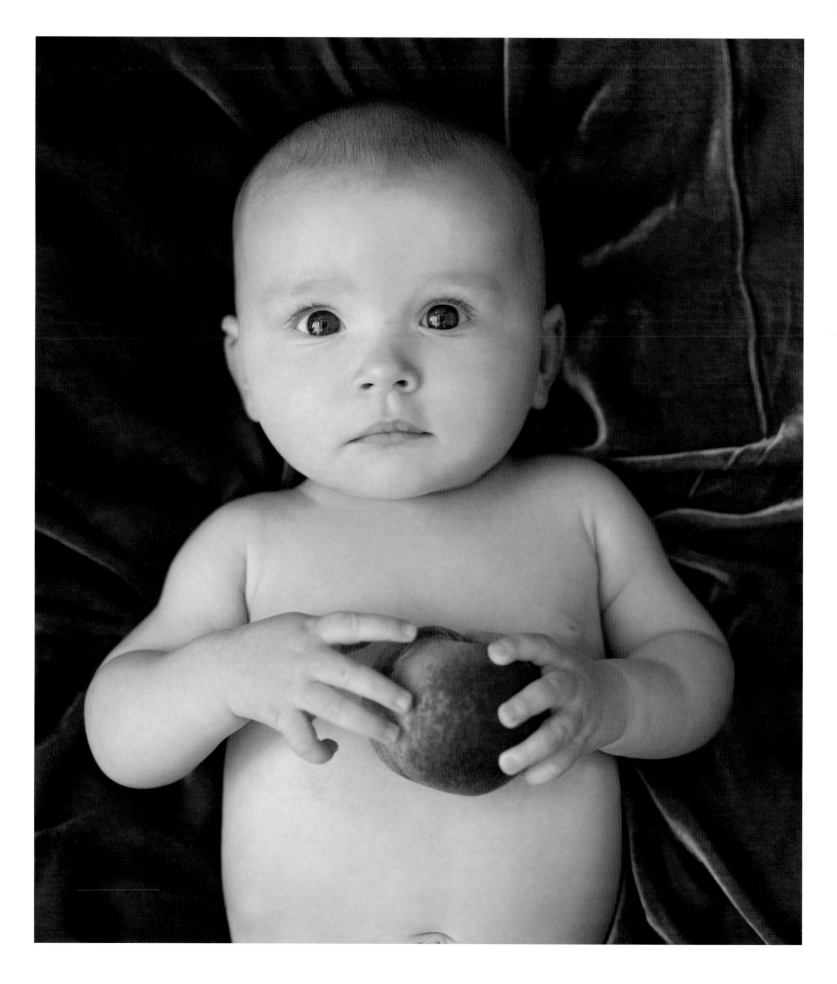

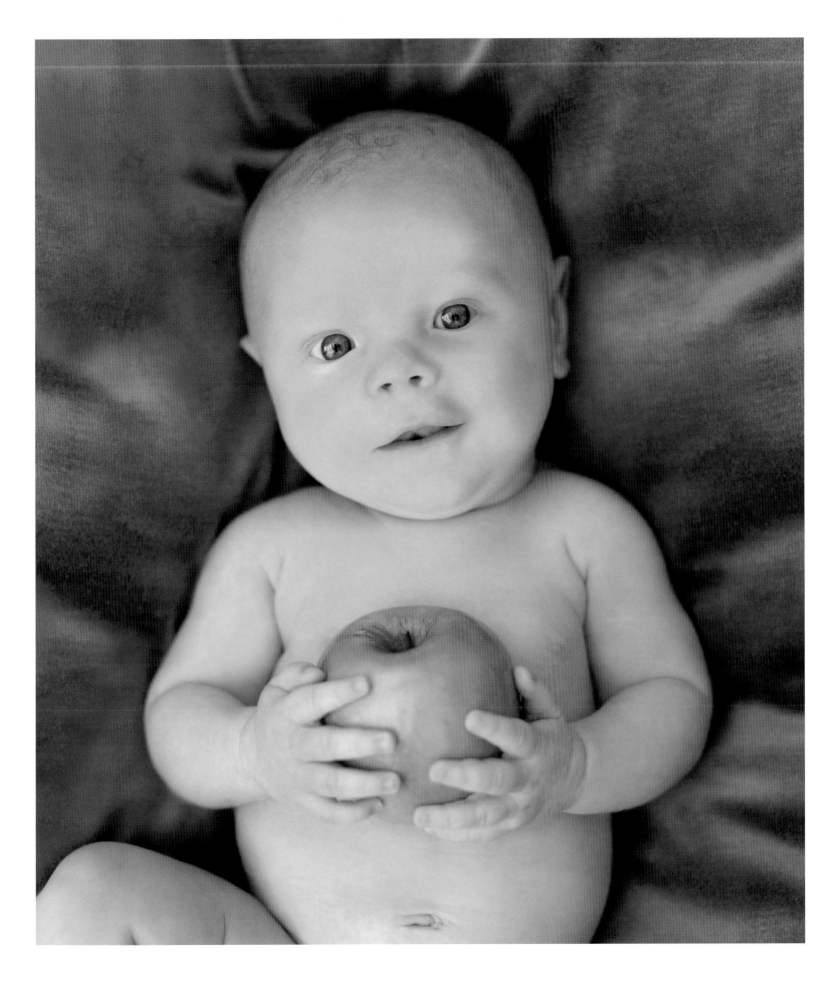

Babies are such a
nice way to start *people*.

DON HEROLD

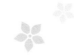

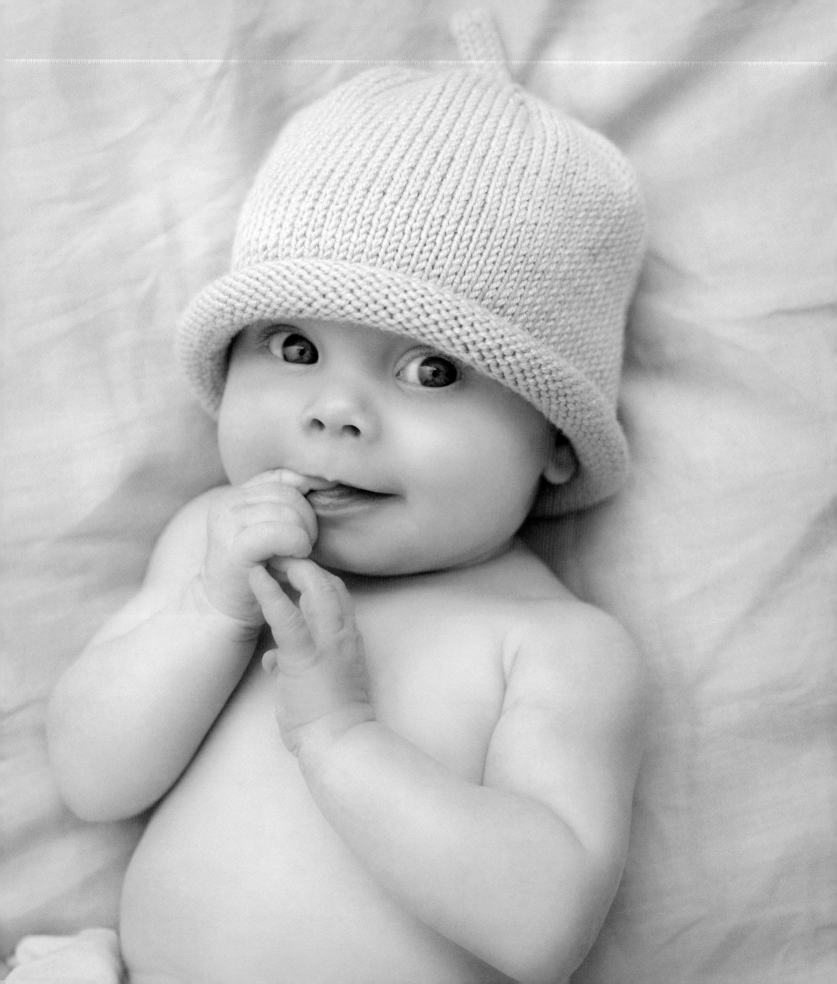

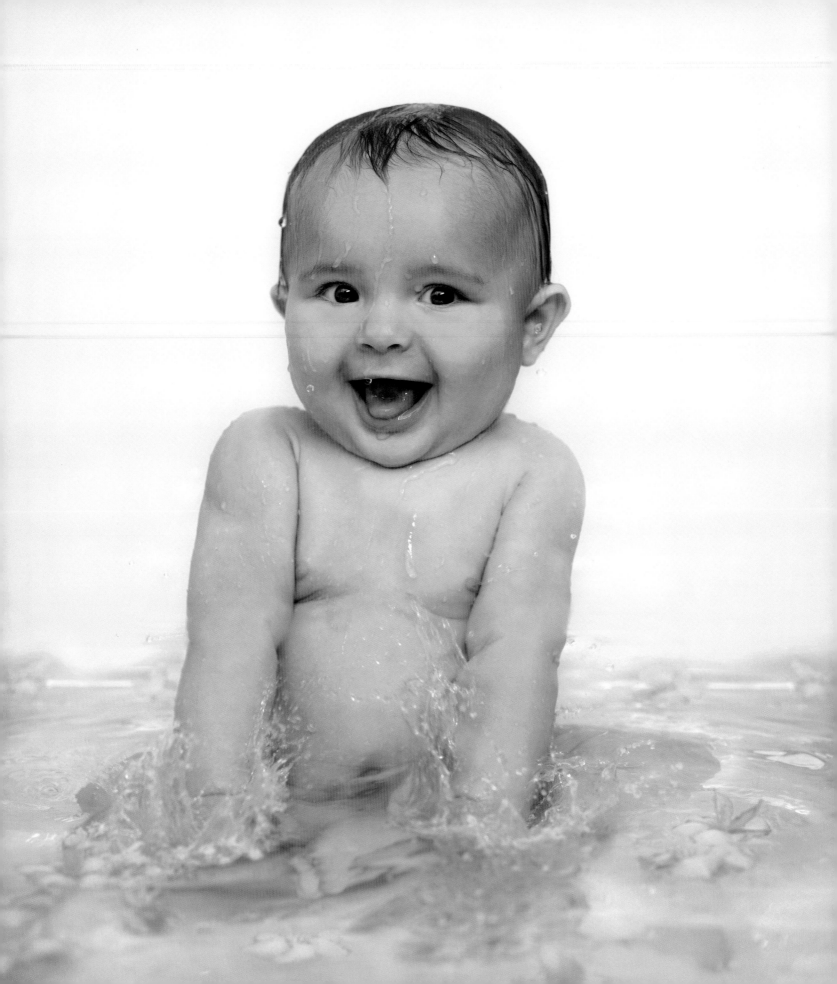

It is the nature of babies
to be in

bliss.

DEEPAK CHOPRA

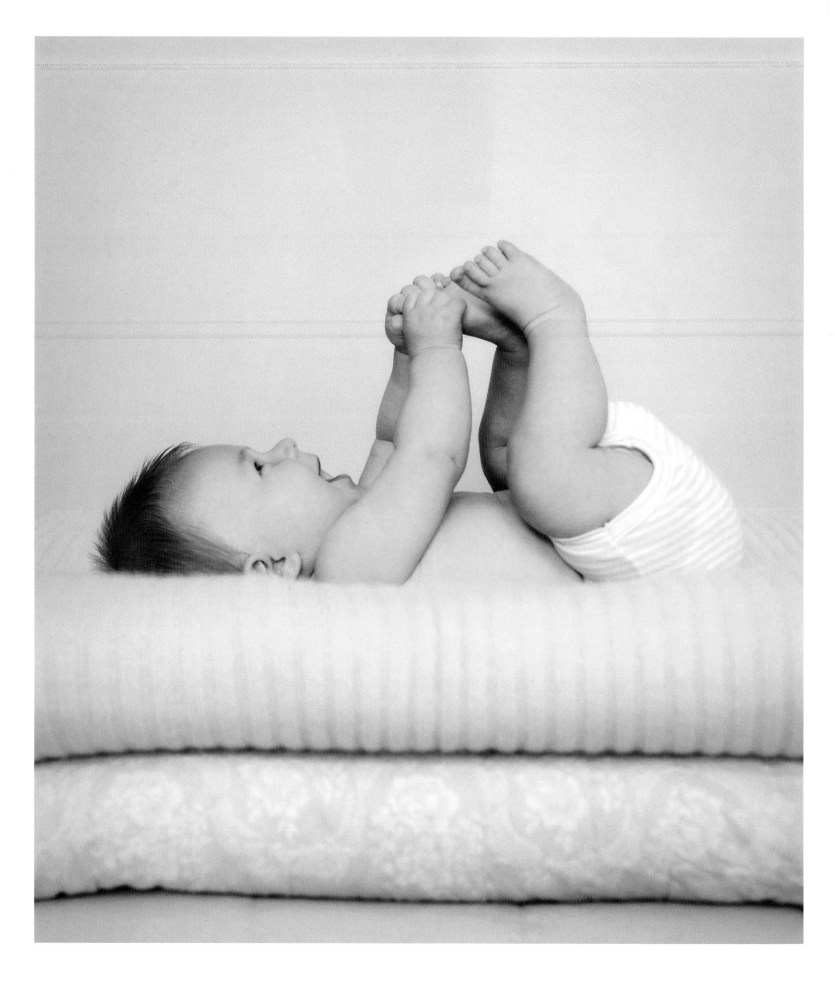

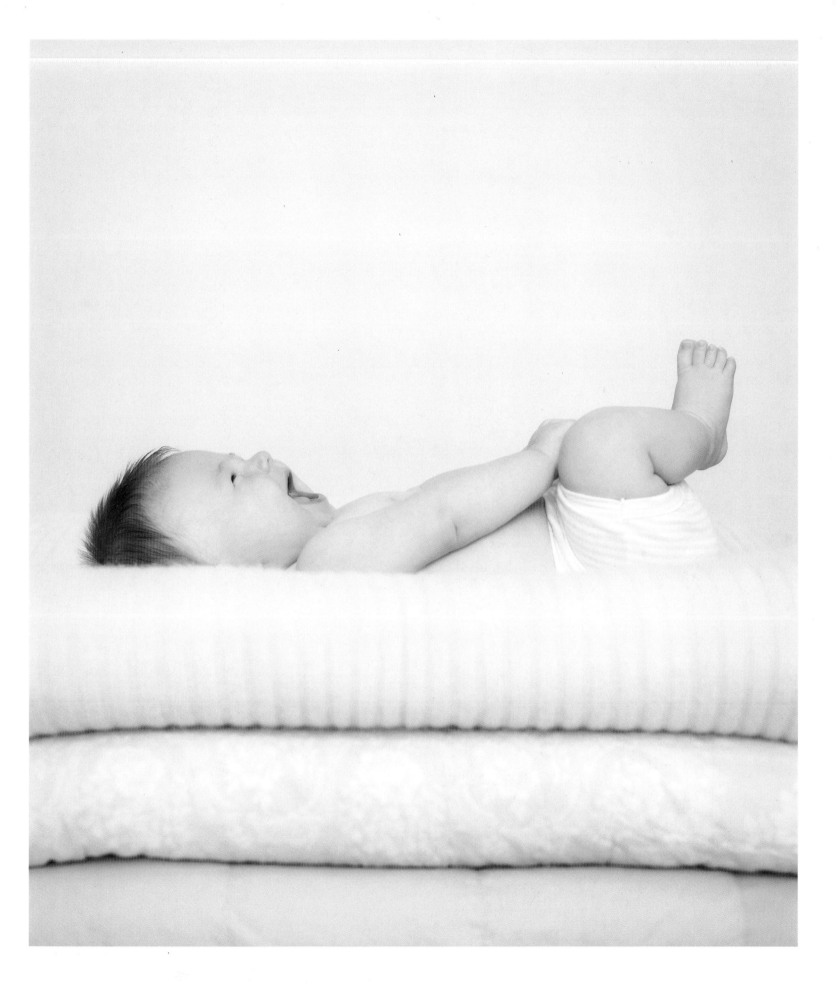

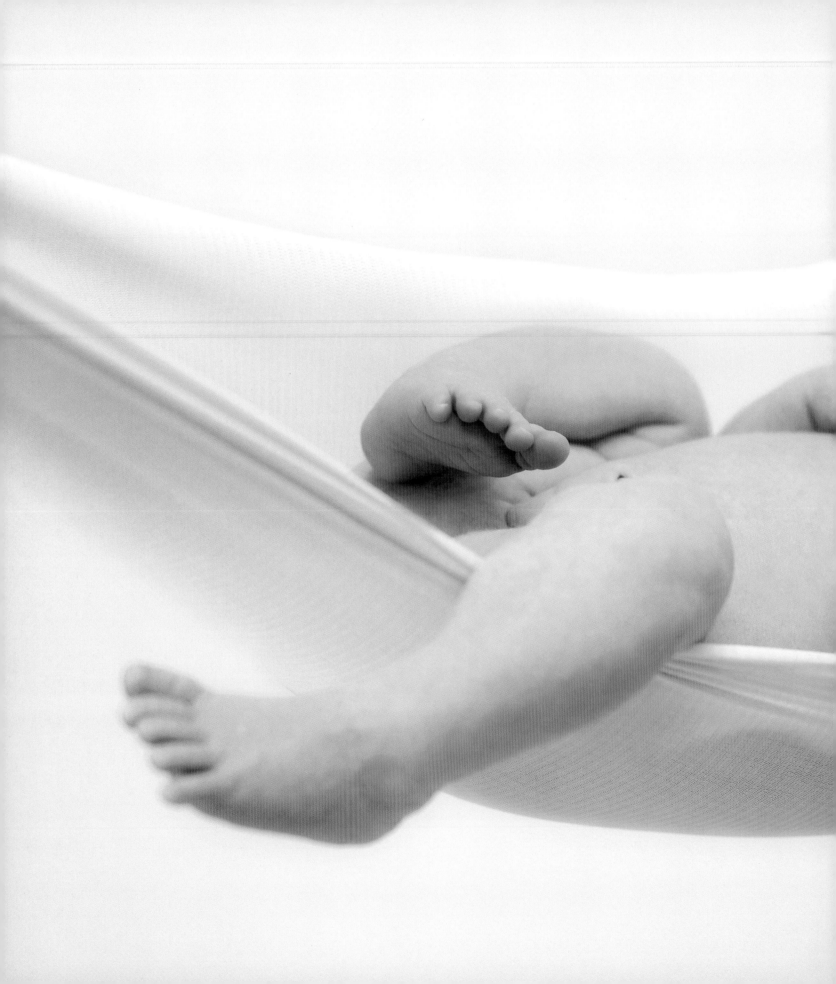

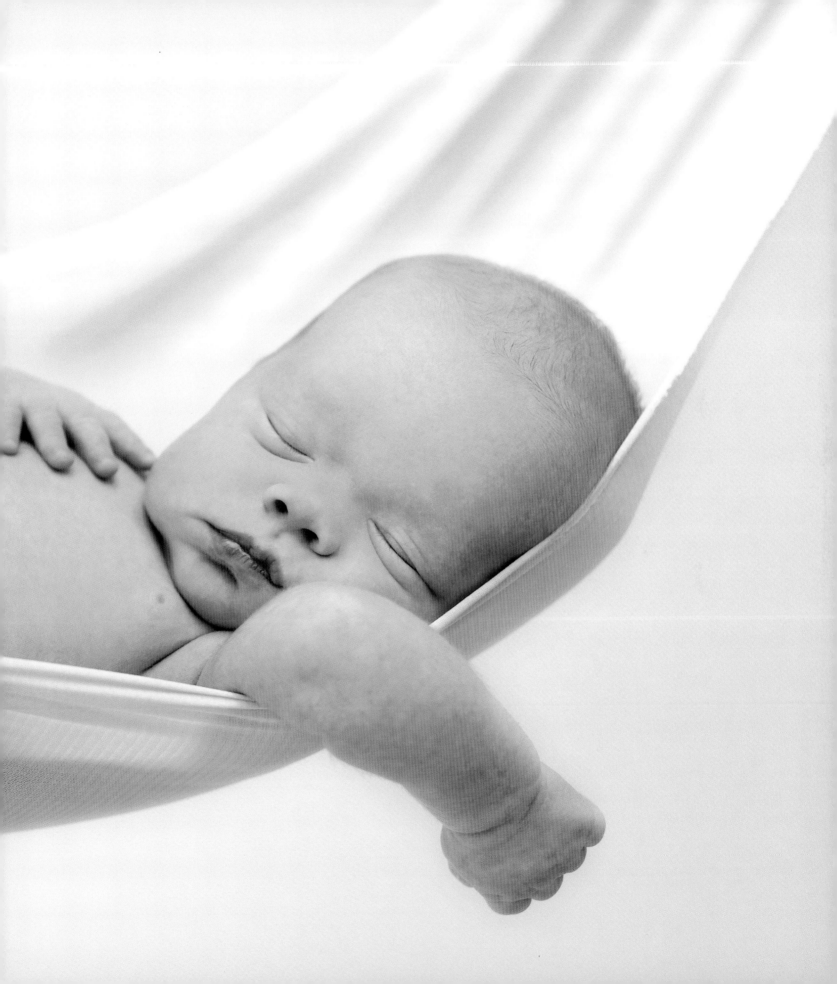

Baby Love, My Baby Love...

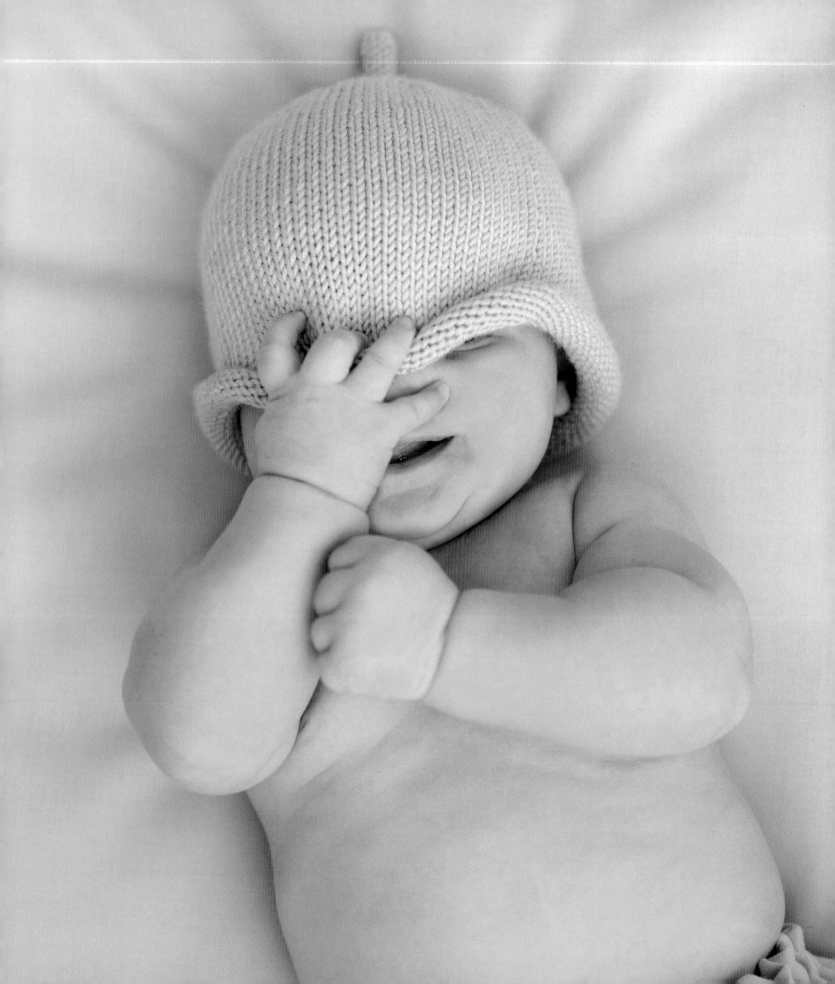

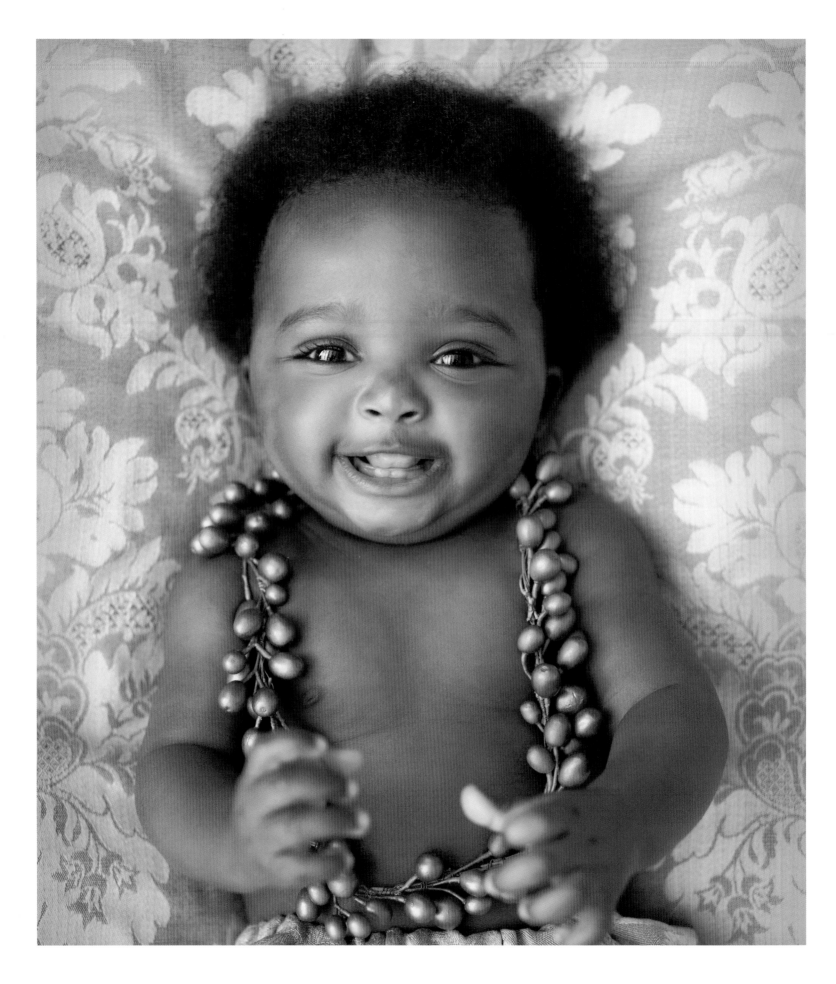

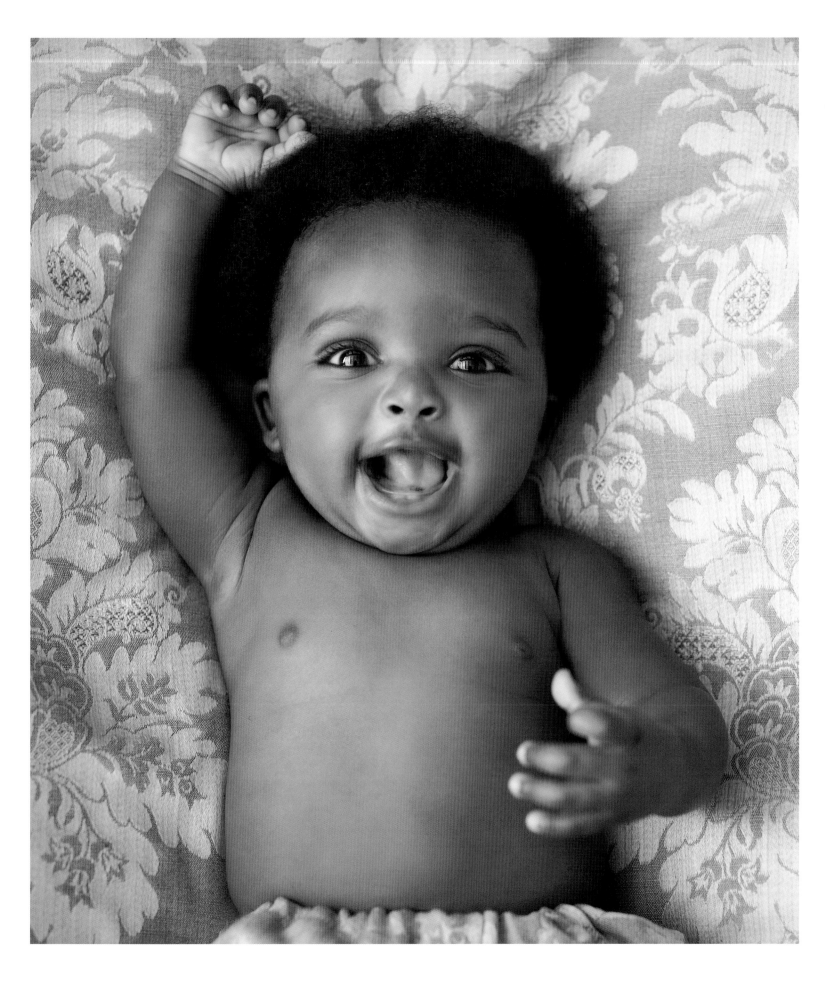

Baby expressions...

A babe in arms: One too young to walk and so must be carried.

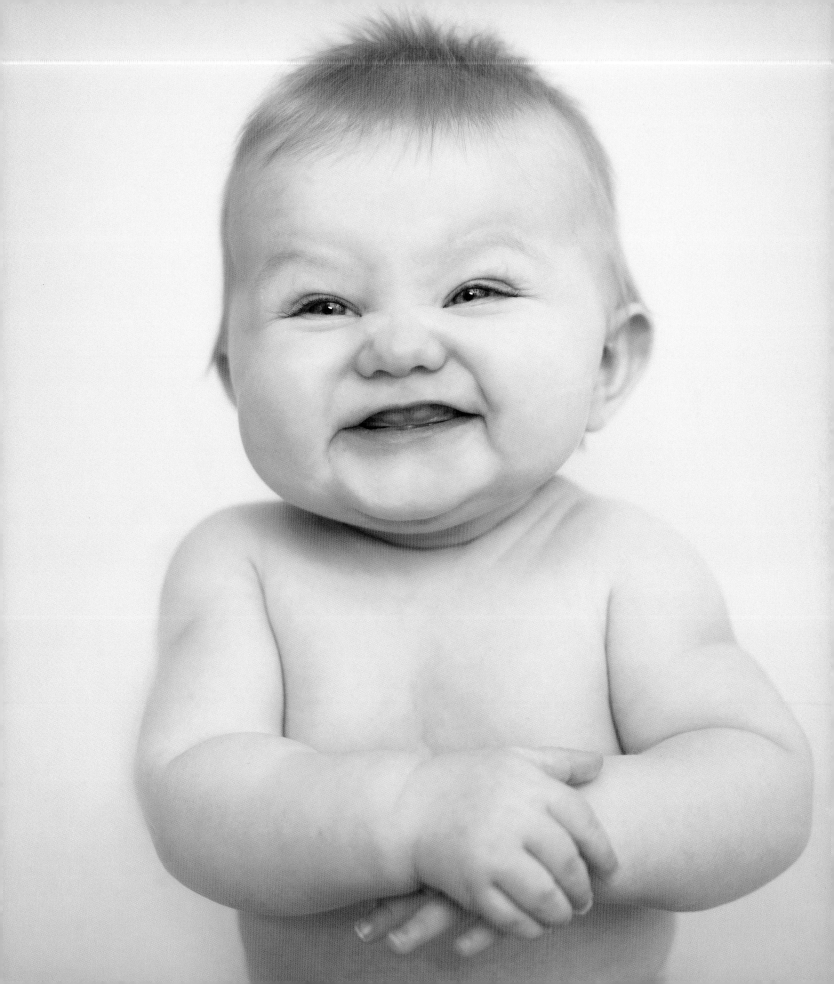

You are my sunshine.

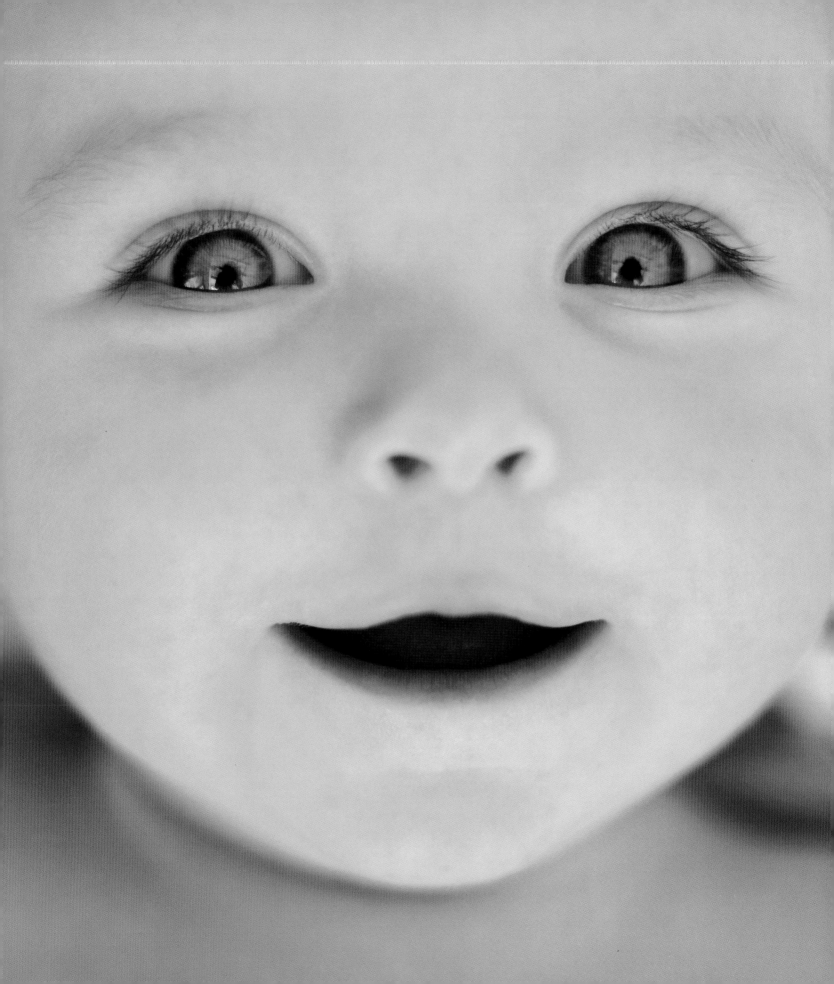

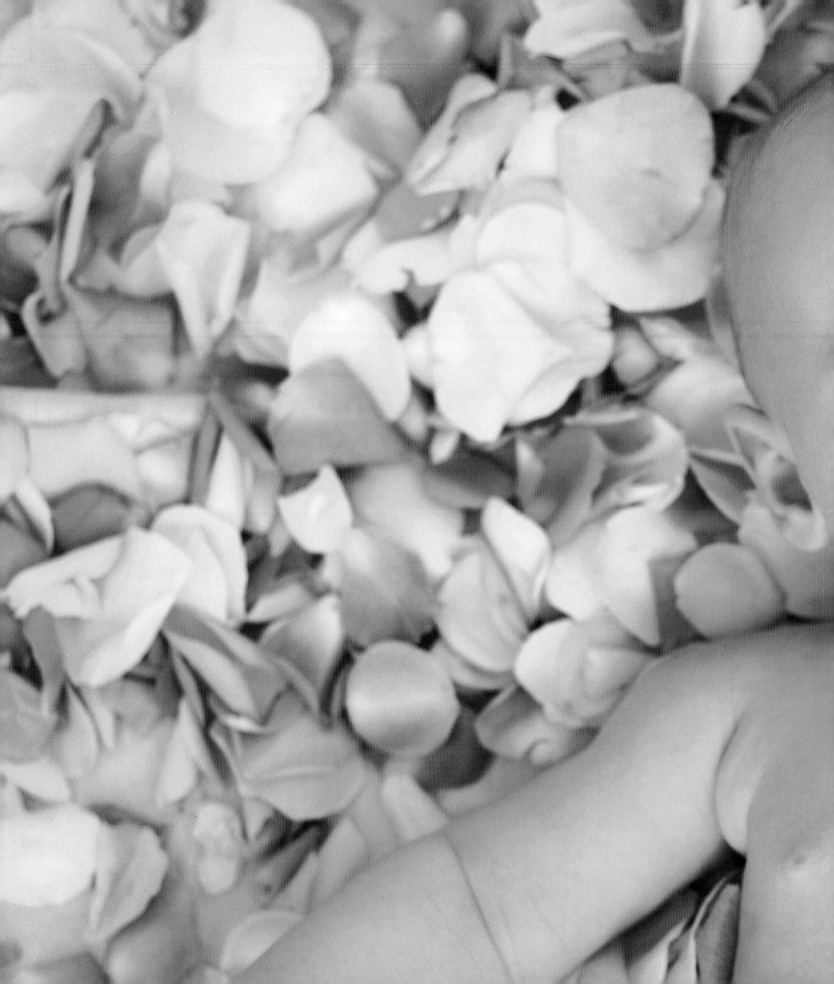

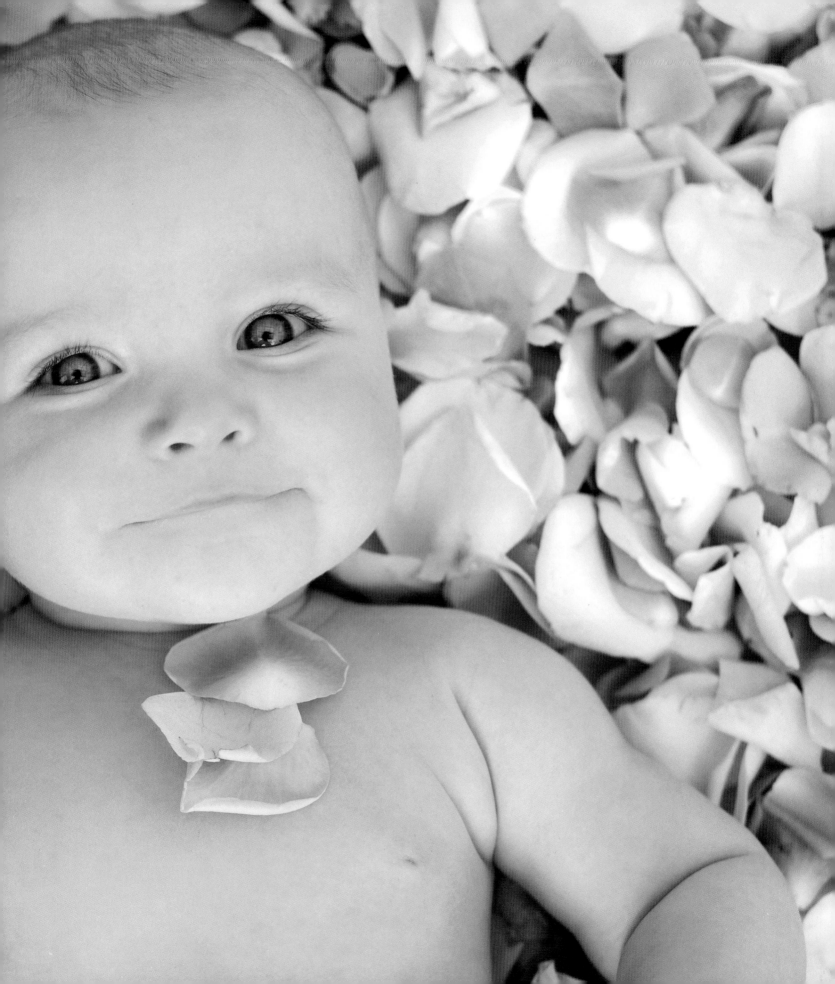

Lullaby

A lullaby is a soothing song, usually sung to children before they go to sleep. One of the most famous lullabies is "Rock-a-bye Baby." Although the author of this lullaby isn't known, the *Great American Baby Almanac* says that it was written by a *Mayflower* pilgrim after observing Wampanoag Native Americans suspending their babies' cradleboards in trees during nice weather so the wind would rock them to sleep.

Rock – a – bye ba – by

Rock-a-bye baby on the tree top,
When the wind blows the cradle will rock,
When the bough breaks the cradle will fall,
And down will come baby, cradle and all.

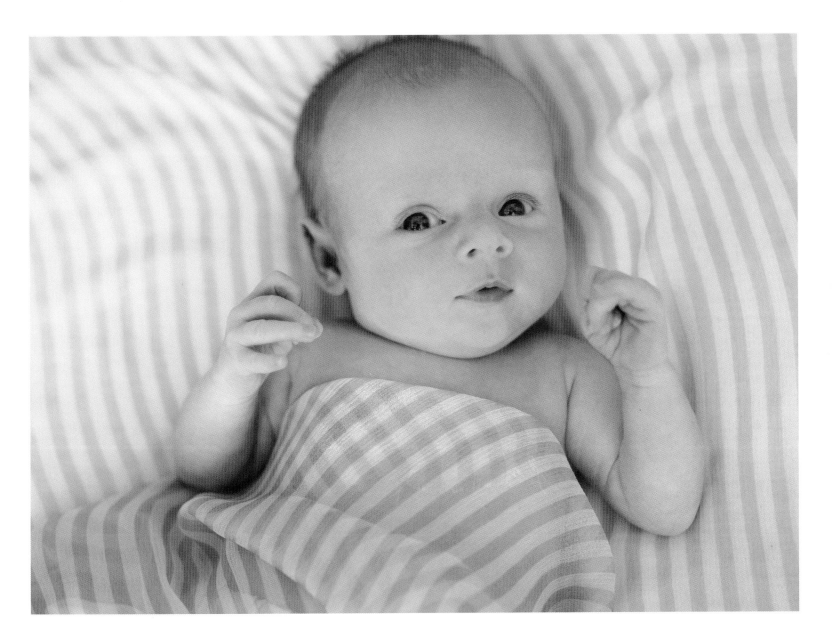

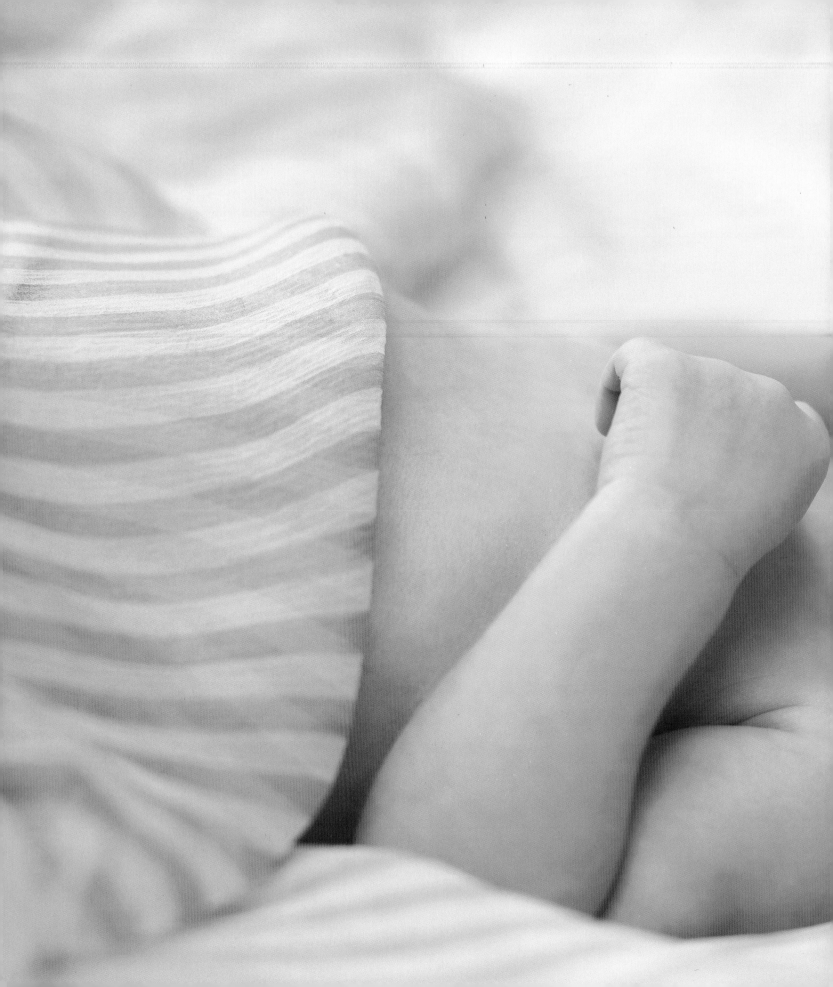

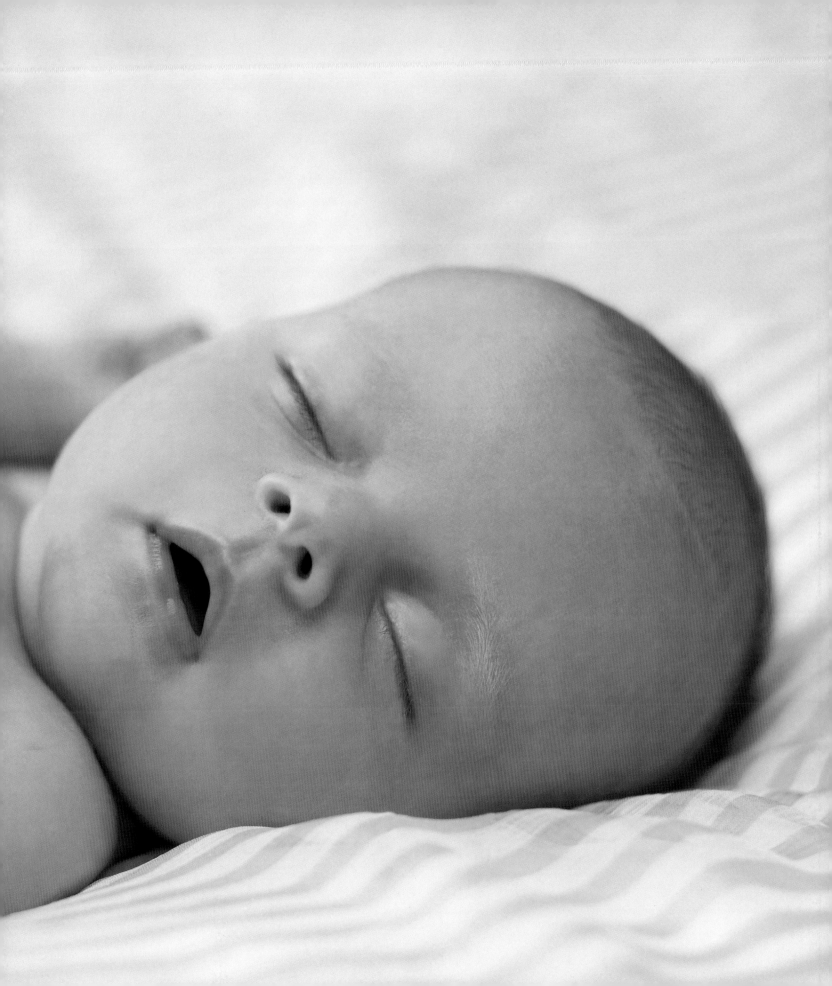

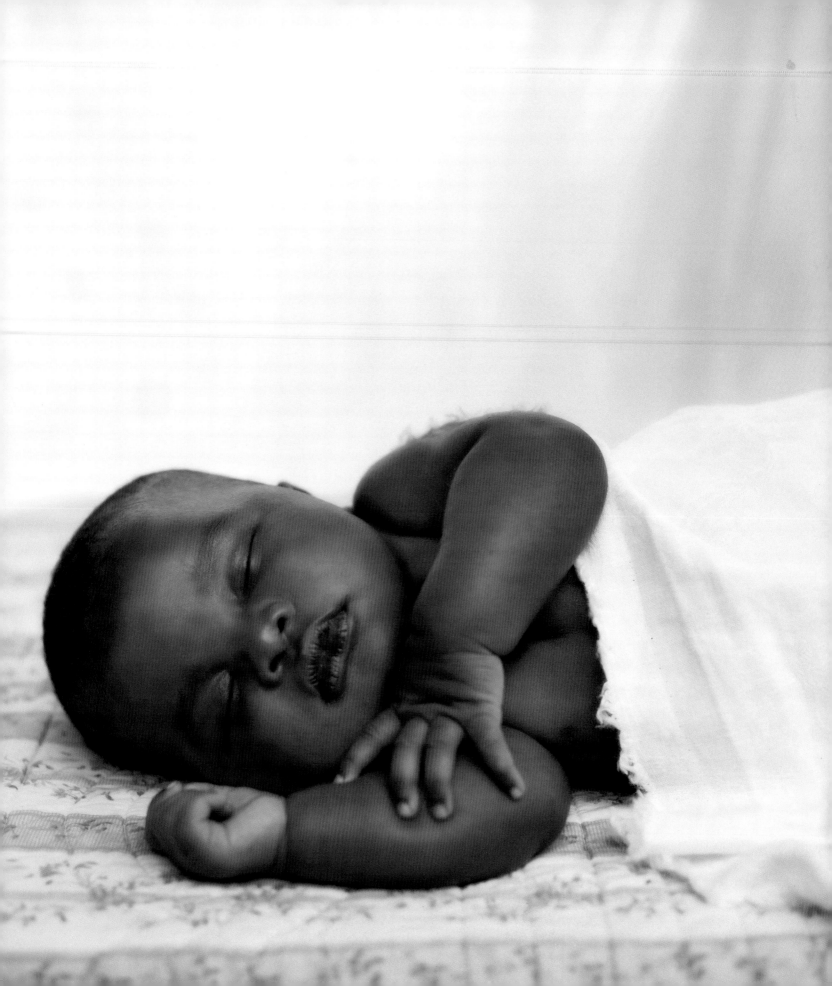

There was never a child so lovely but his mother was glad to get him to sleep.

RALPH WALDO EMERSON

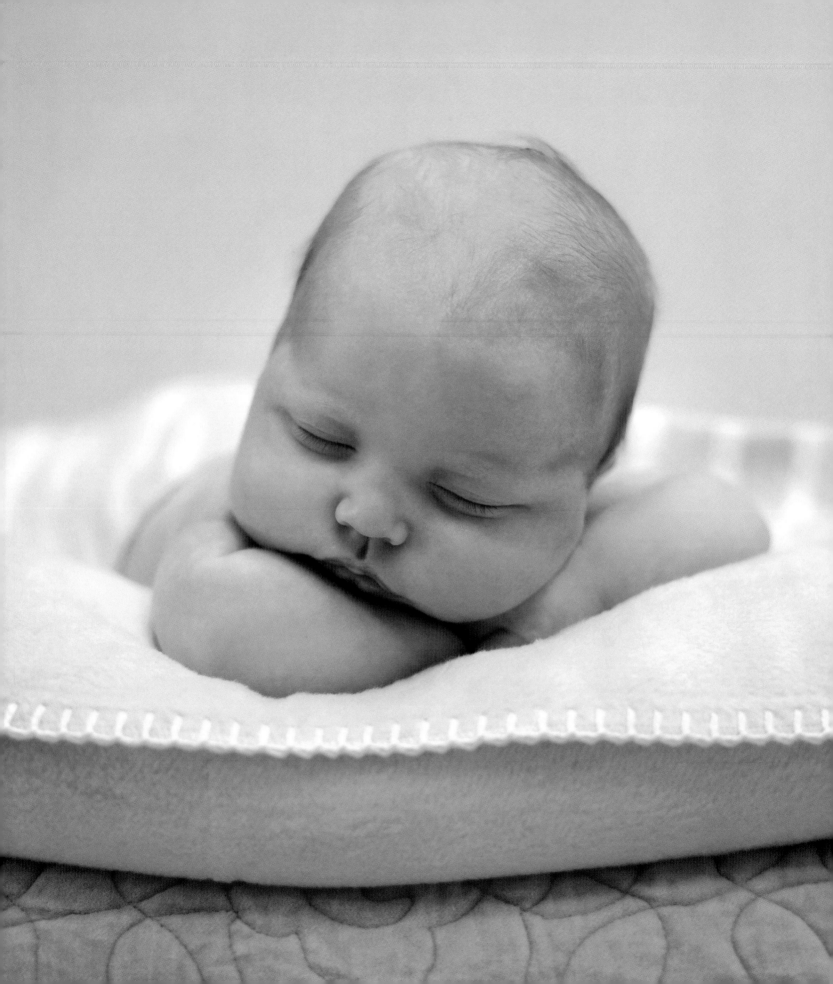

Shhhhh...

Sleeping baby...

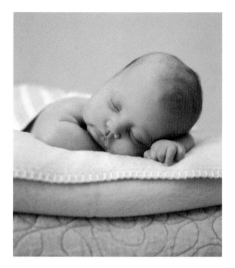
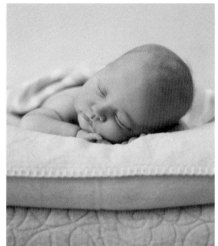
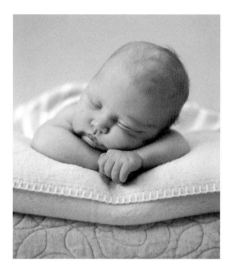
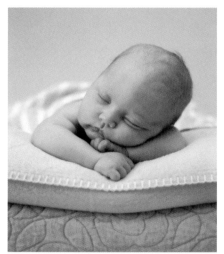
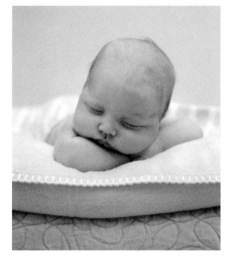
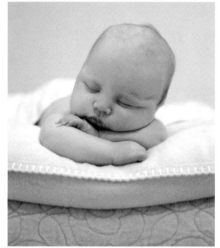
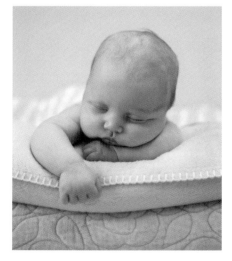
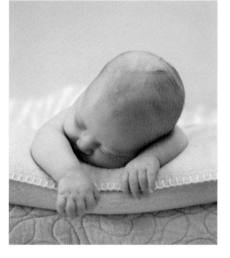
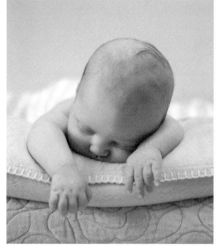

The smile that flickers on baby's lips
when baby sleeps—does anybody know where it was born?
Yes, there is a rumor that a young pale beam of a
crescent moon touched the edge of a vanishing autumn cloud,
and there the smile was first born…

RABINDRANATH TAGORE

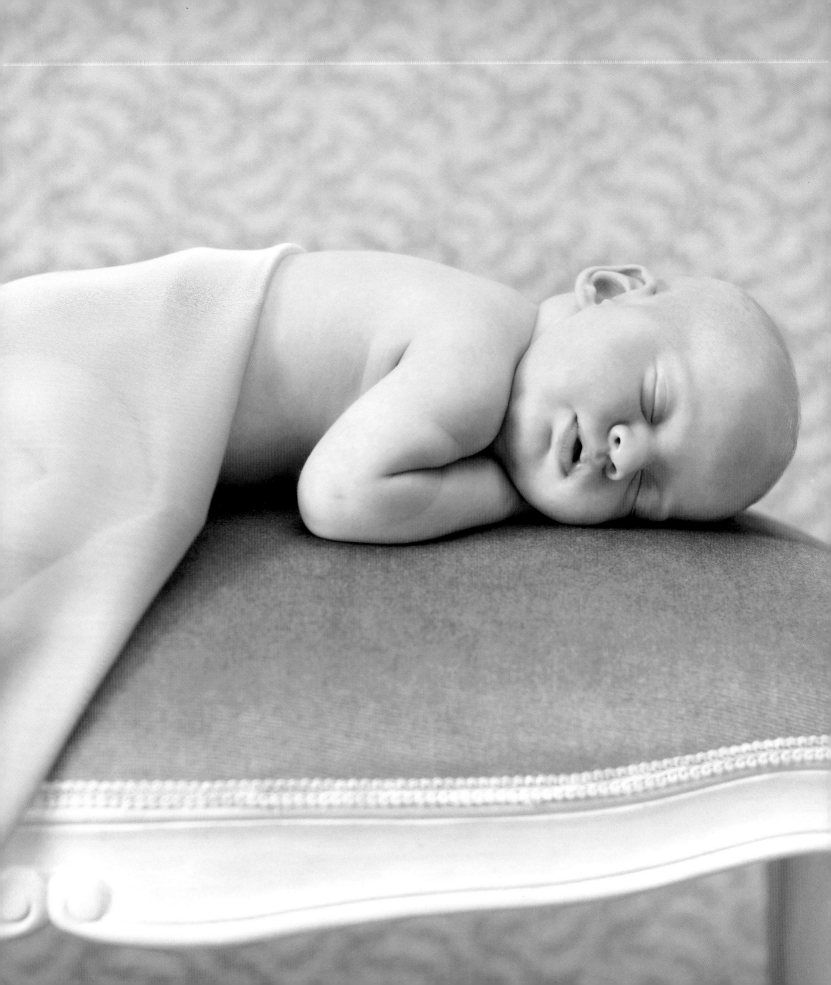

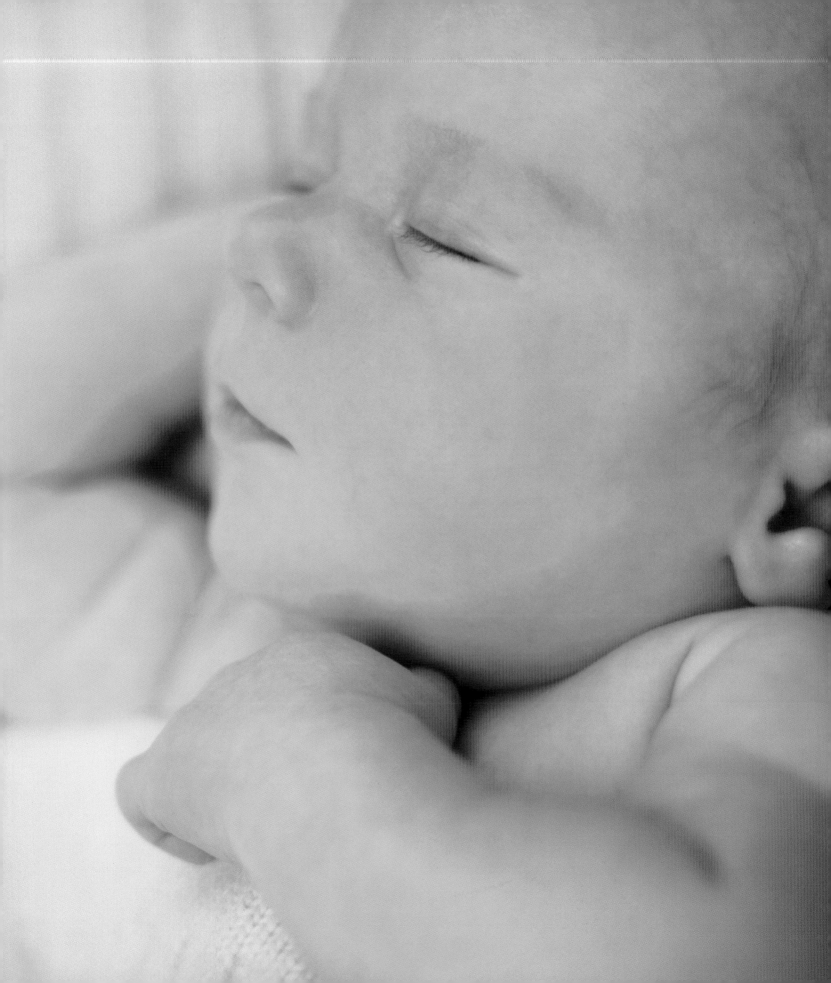

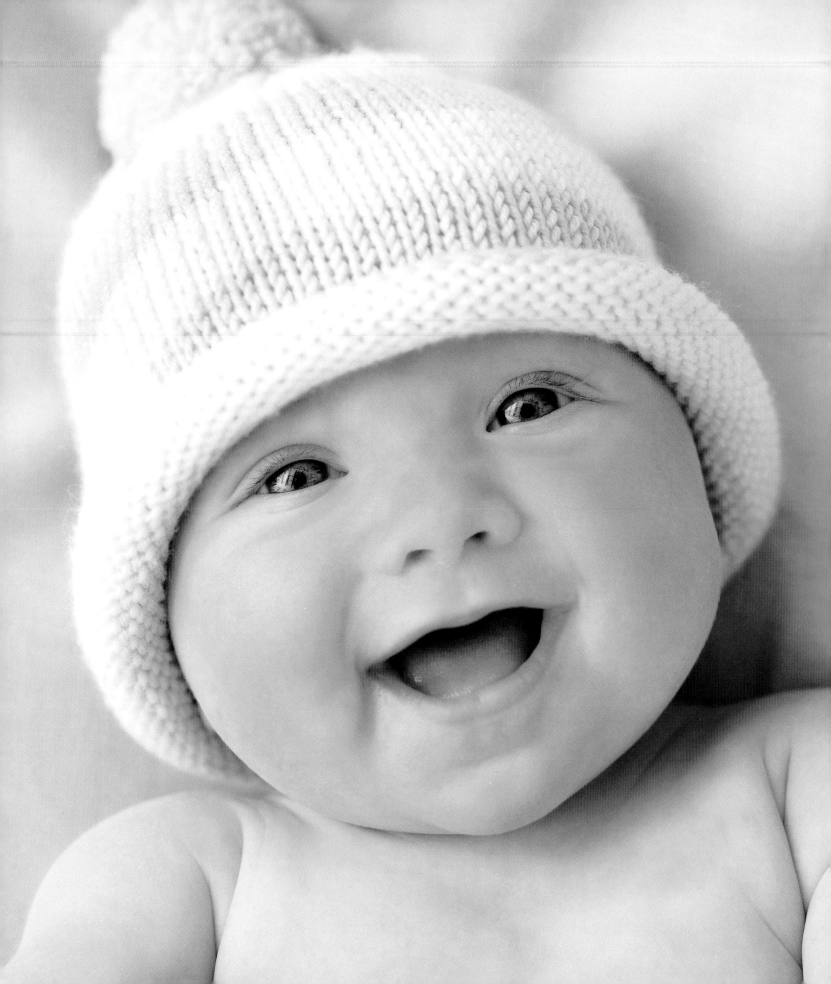

Baby definition...

Baby: Bewildering Ability to Bewitch You.

Monday's Child ✽

Monday's child is fair of face,

Tuesday's child is full of grace,

Wednesday's child is full of woe,

Thursday's child has far to go,

Friday's child is loving and giving,

Saturday's child work's hard for its living,

And a child that's born on the Sabbath day,

Is fair and wise and good and gay.

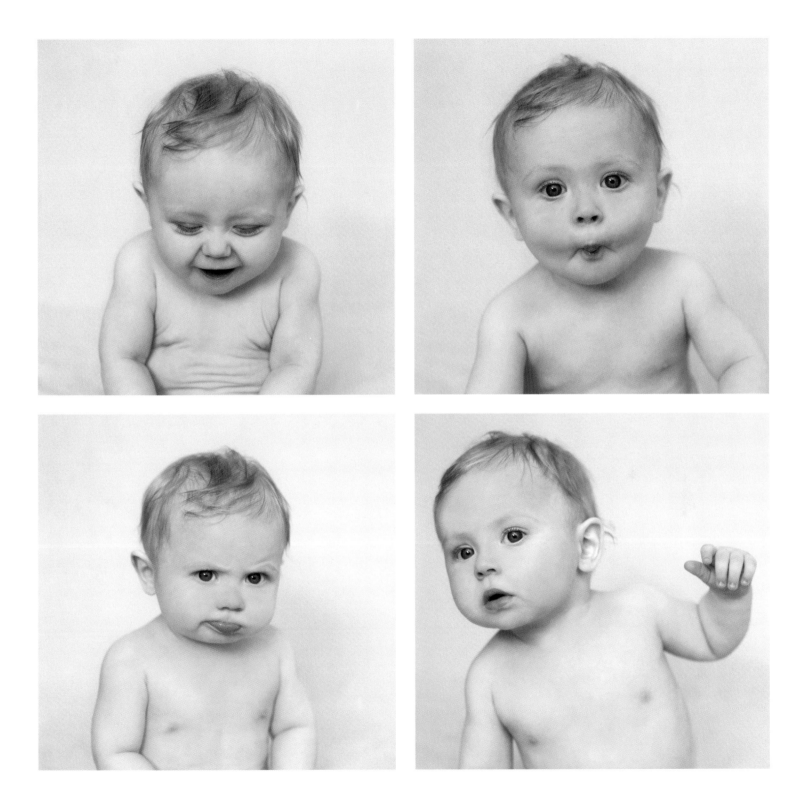

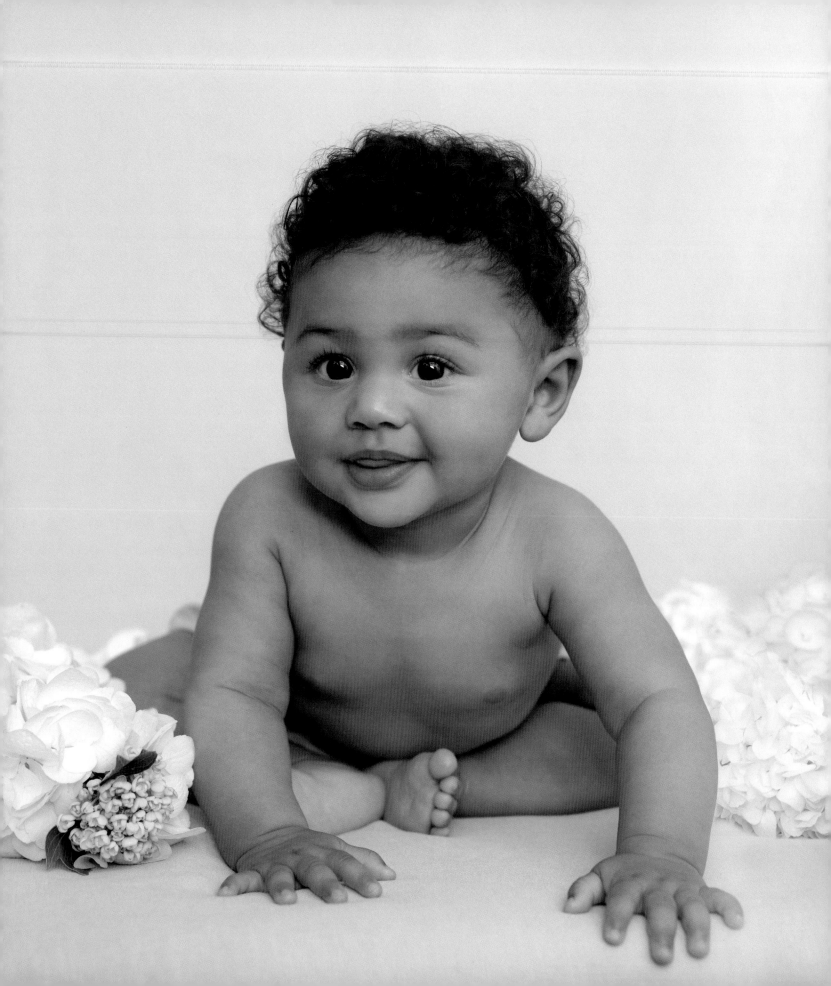

Every baby born into the world
is a finer one than the last.

CHARLES DICKENS

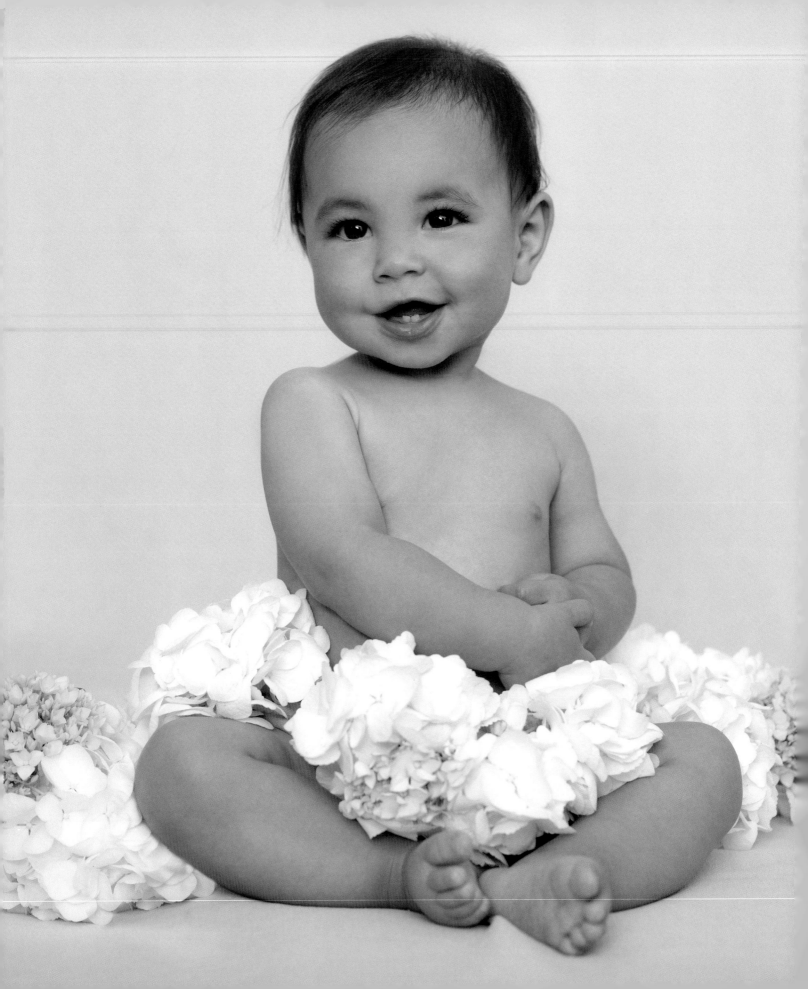

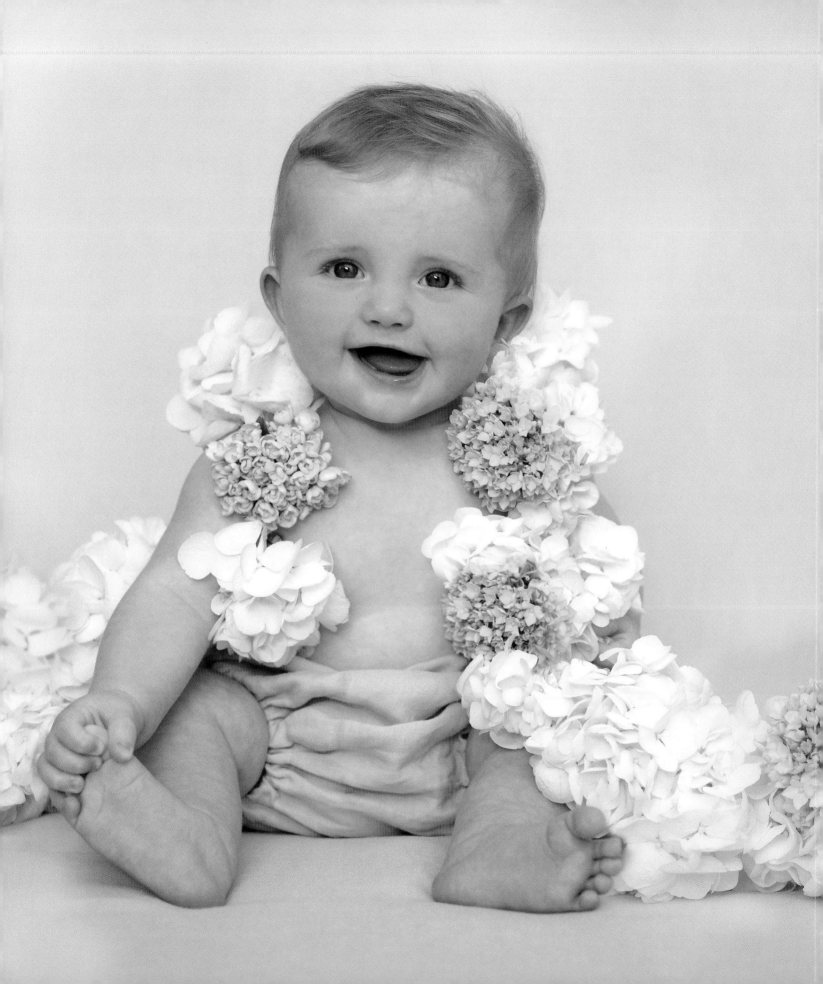

Baby expressions…

Babes in the wood: A phrase humorously applied to simple, trustful folks, who are never suspicious and are easily fooled.

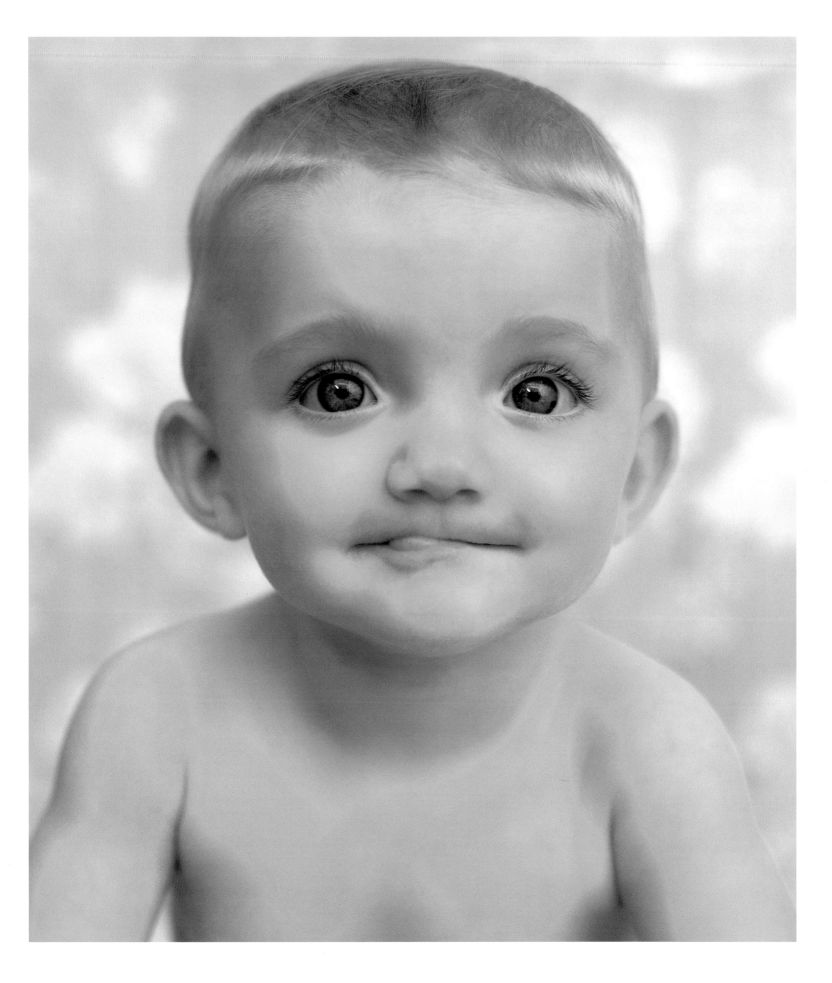

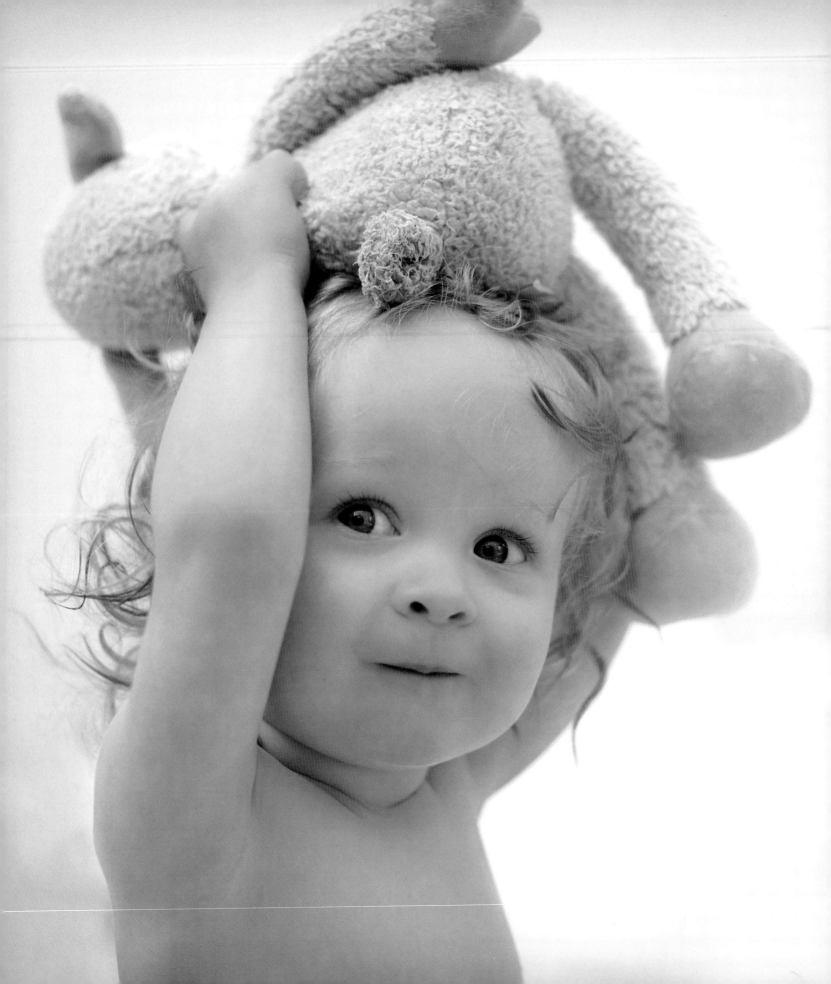

THE
Teddy Bear

He sat down on the floor, holding the bear tightly in his arms, wave after wave of relief washing over him in a warm, relaxing flood. All his life long, ever since he could remember, more than three years now, he had gone to sleep with his big Teddy in his arms. The sight of the faithful pointed face, like no other face, the friendly staring black eyes, the familiar feel of the dear, woolly body close to him—they were saturated with a thousand memories of peace, with a thousand associations of comfort and escape from trouble.

From *The Home Maker* by DOROTHY CANFIELD

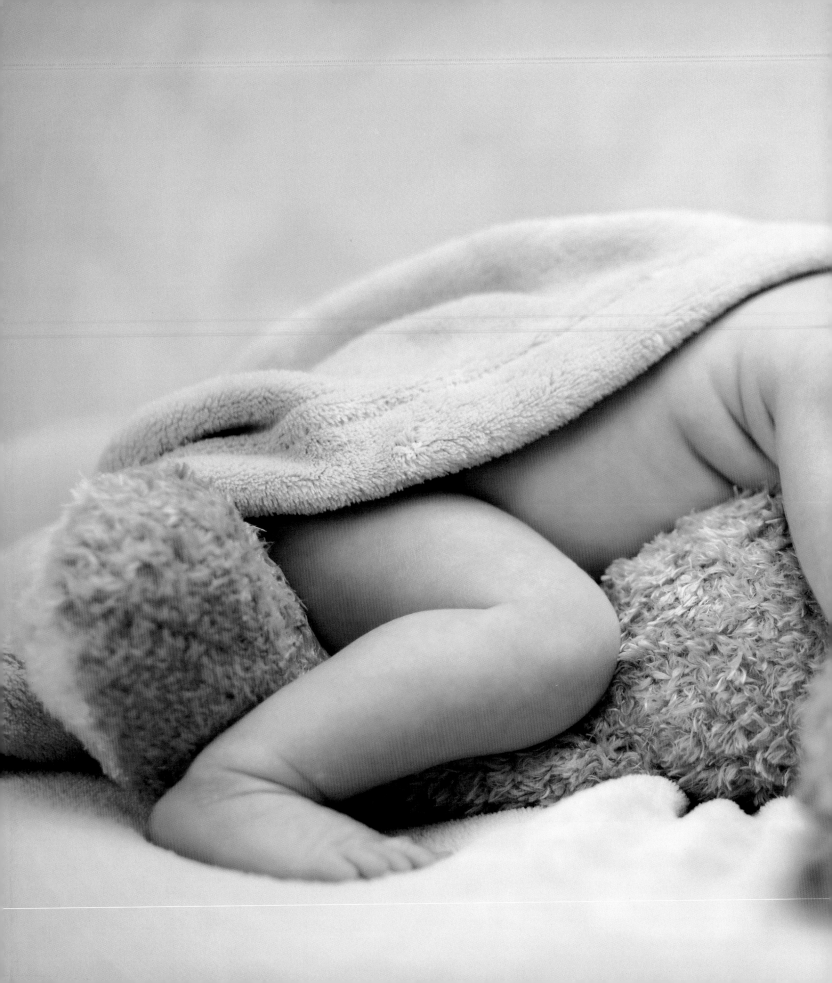

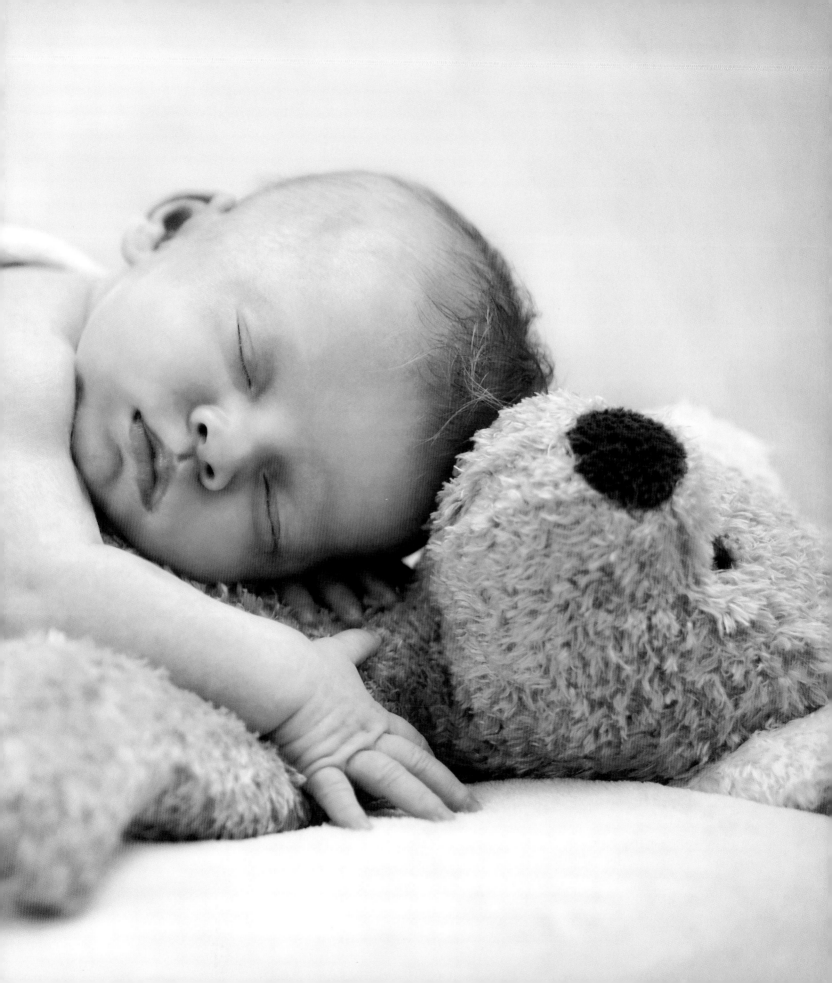

Happiness is loving the skin you're in!

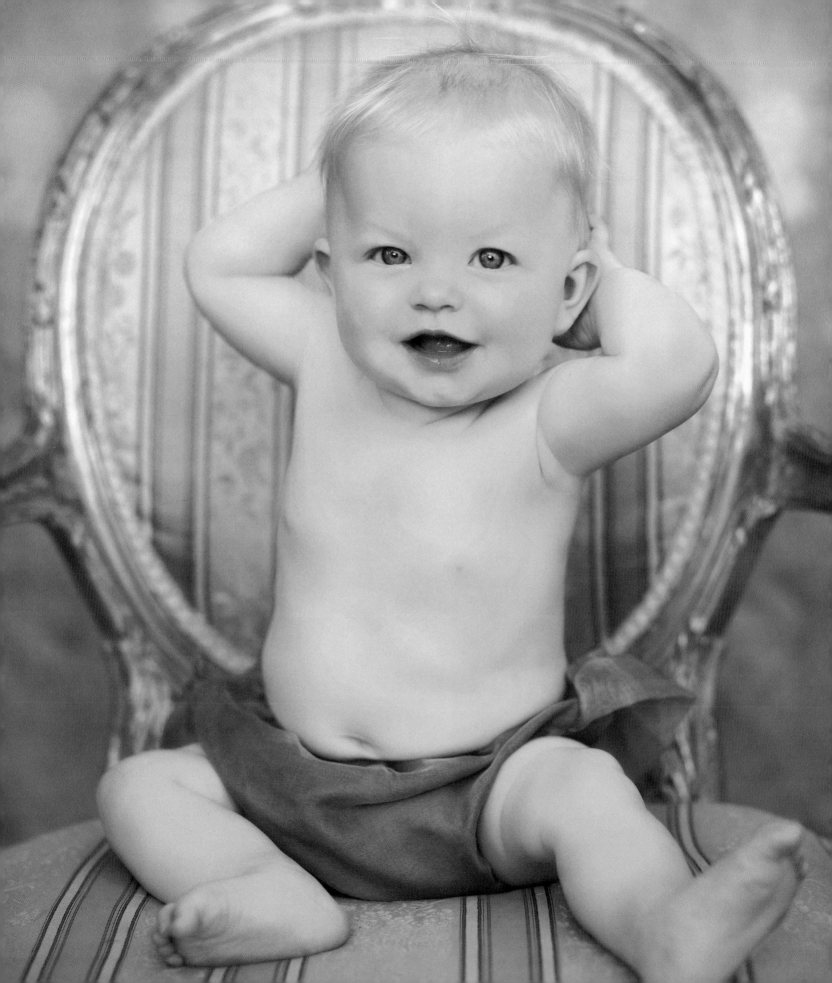

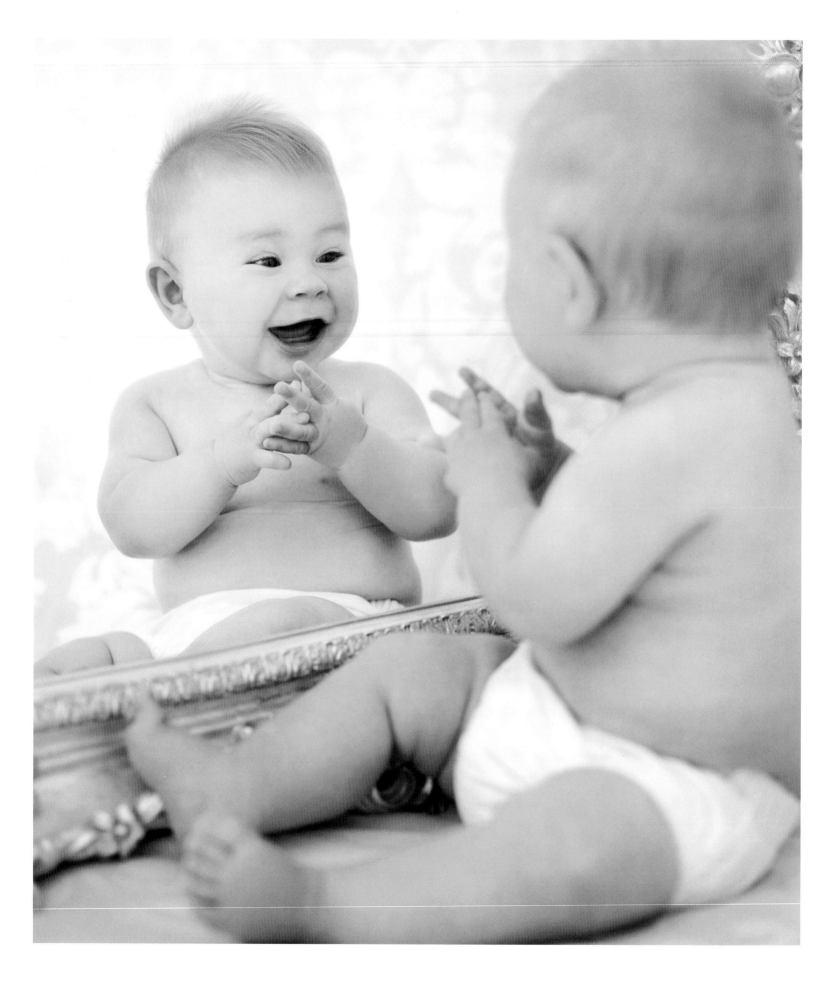

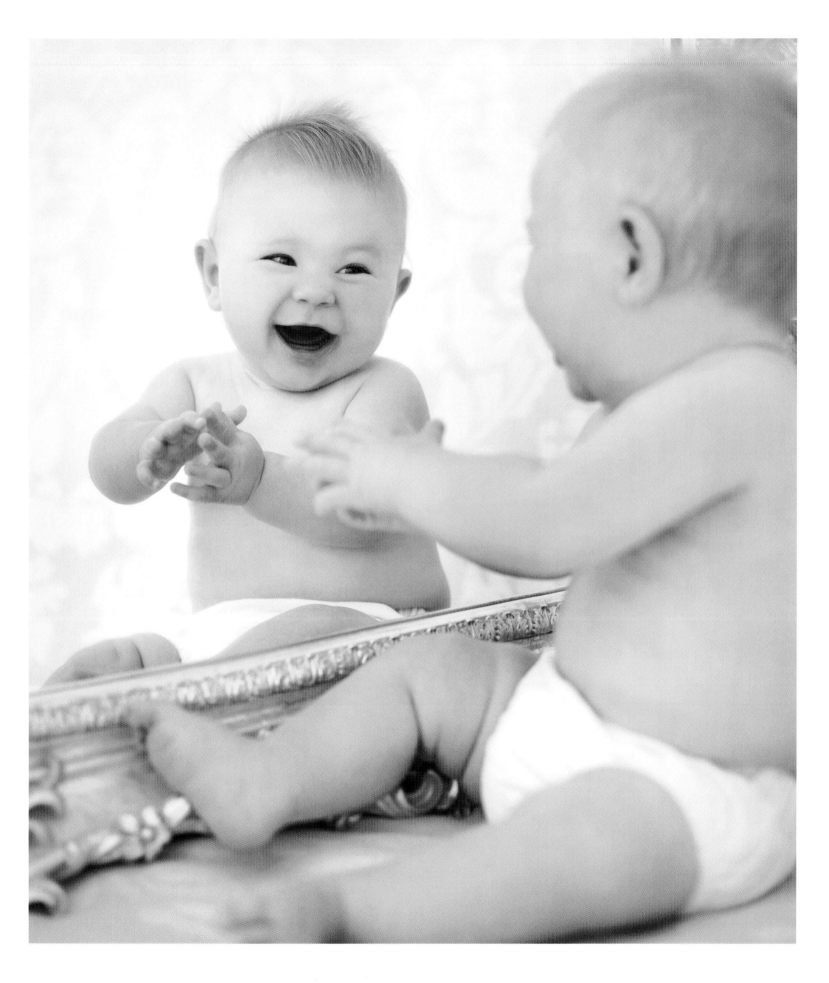

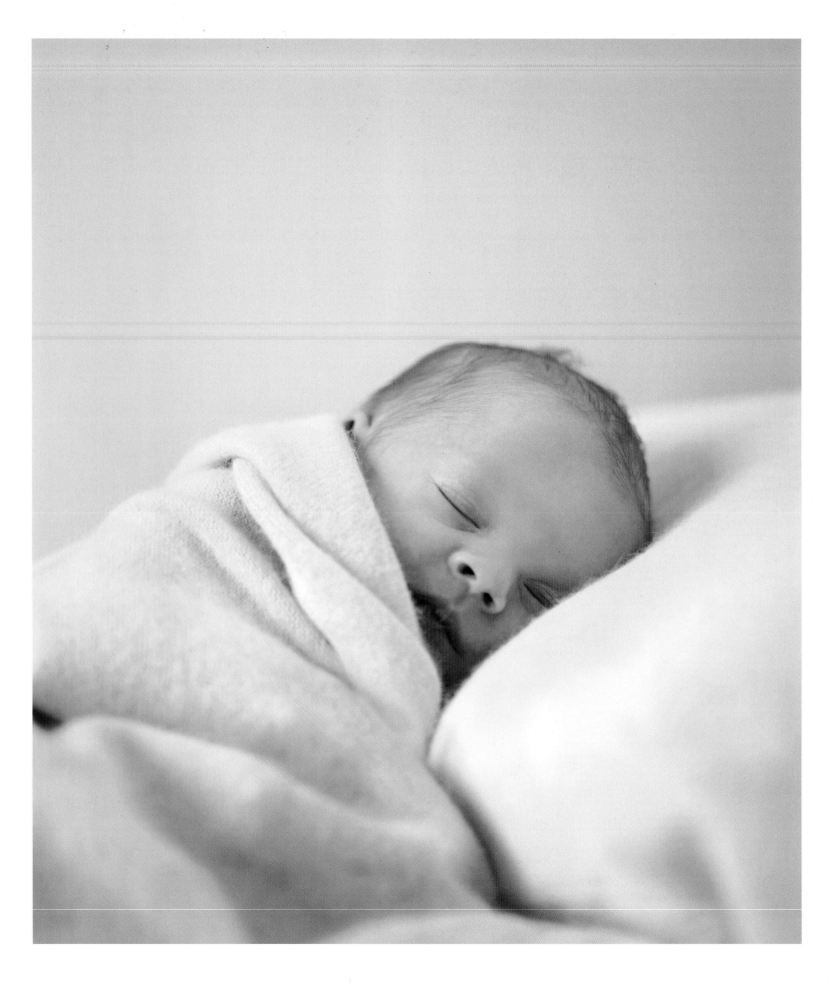

— *Snug as a Bug in a Rug* —

♥

HOW TO SWADDLE A BABY.

1. Lay a blanket on a flat surface and fold down the top-right corner about six inches.

2. Place baby on her back with her head on the fold.

3. Pull the corner near your baby's left hand across her body, and tuck the leading edge under her back on the right side under the arm.

4. Pull the bottom corner up under your baby's chin.

5. Bring the loose corner over your baby's right arm and tuck it under the back on her left side. If your baby prefers to have her arms free, you can swaddle her under the arms. This gives her access to her hands and fingers.

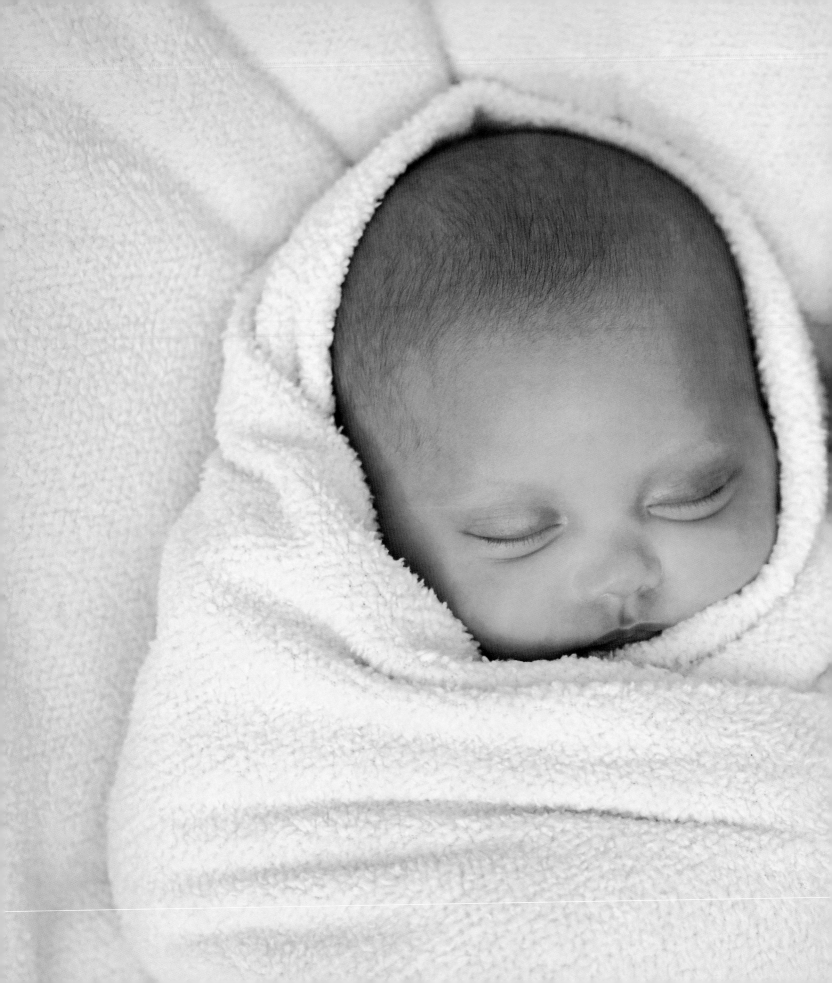

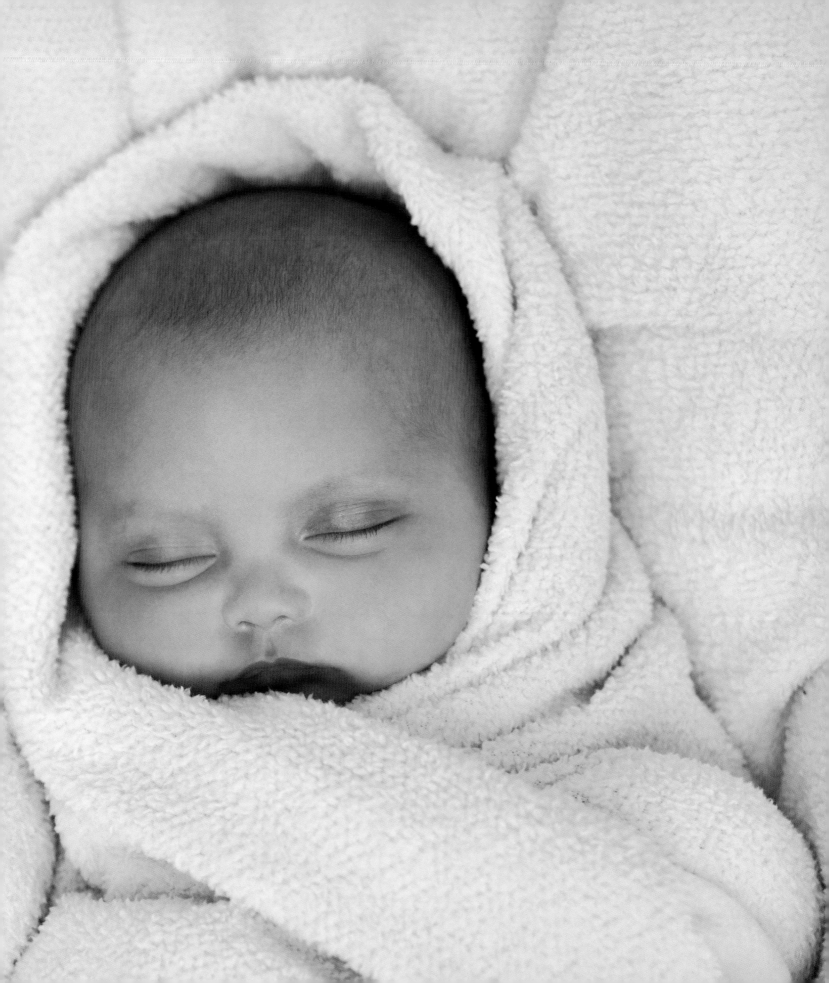

If your baby's
"beautiful and perfect, never cries or fusses,
sleeps on schedule and burps on demand,
an angel all the time,"
you're the grandma.

TERESA BLOOMINGDALE

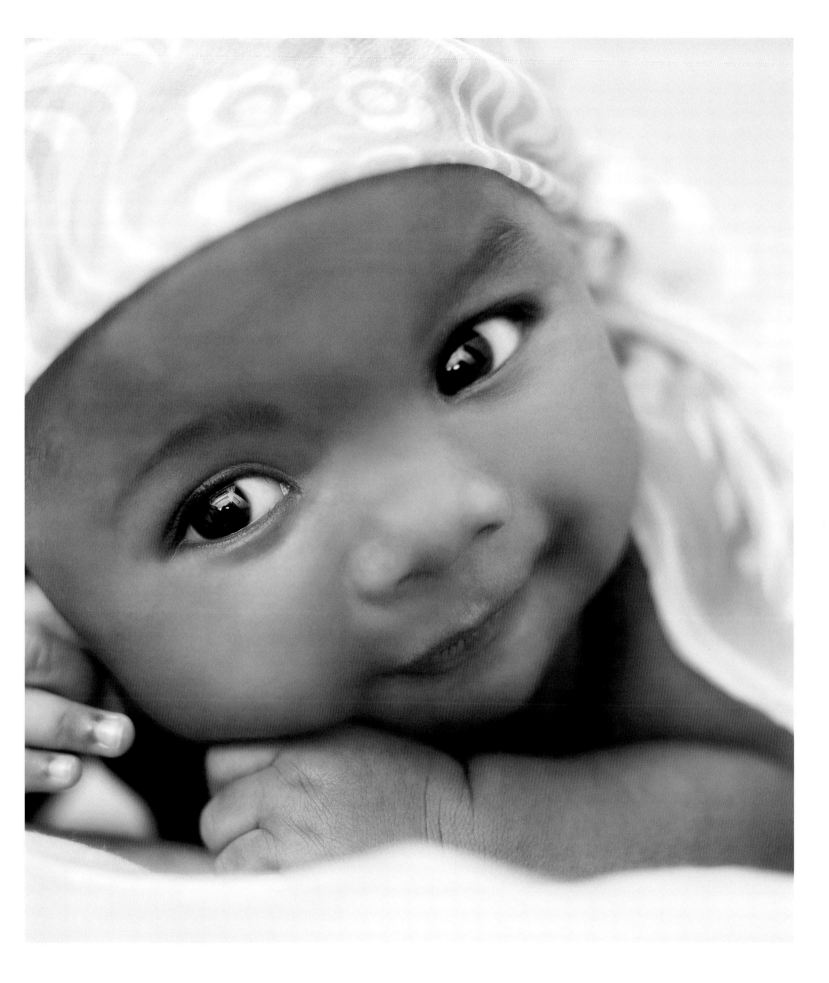

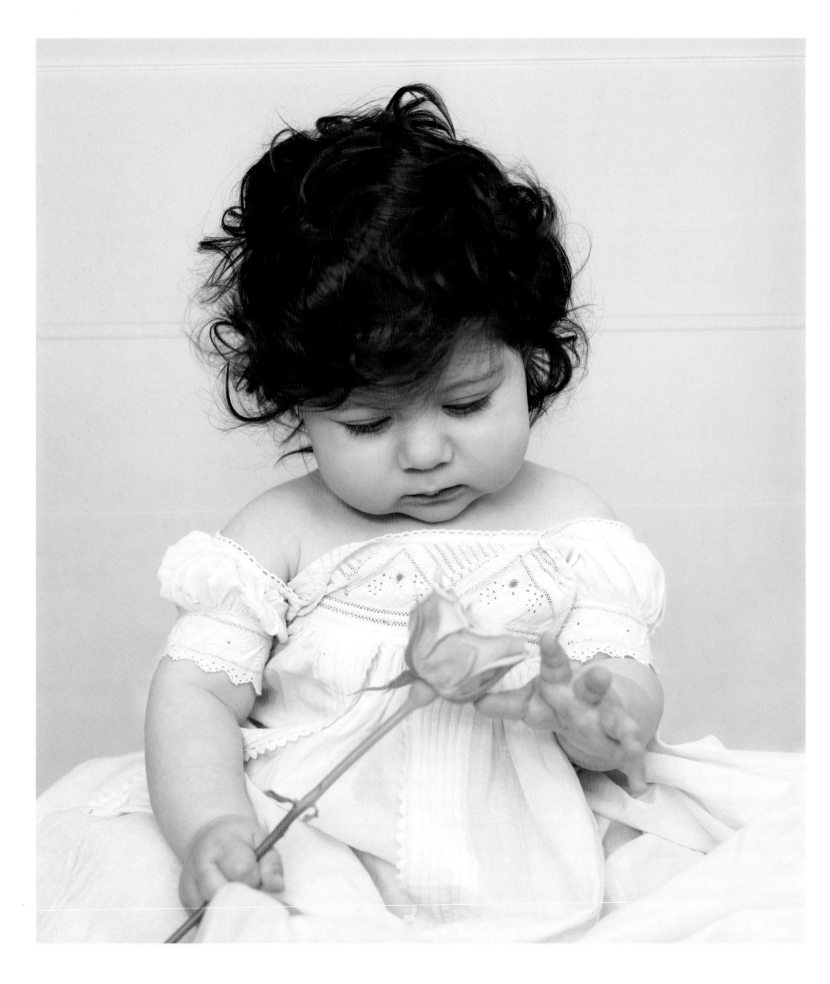

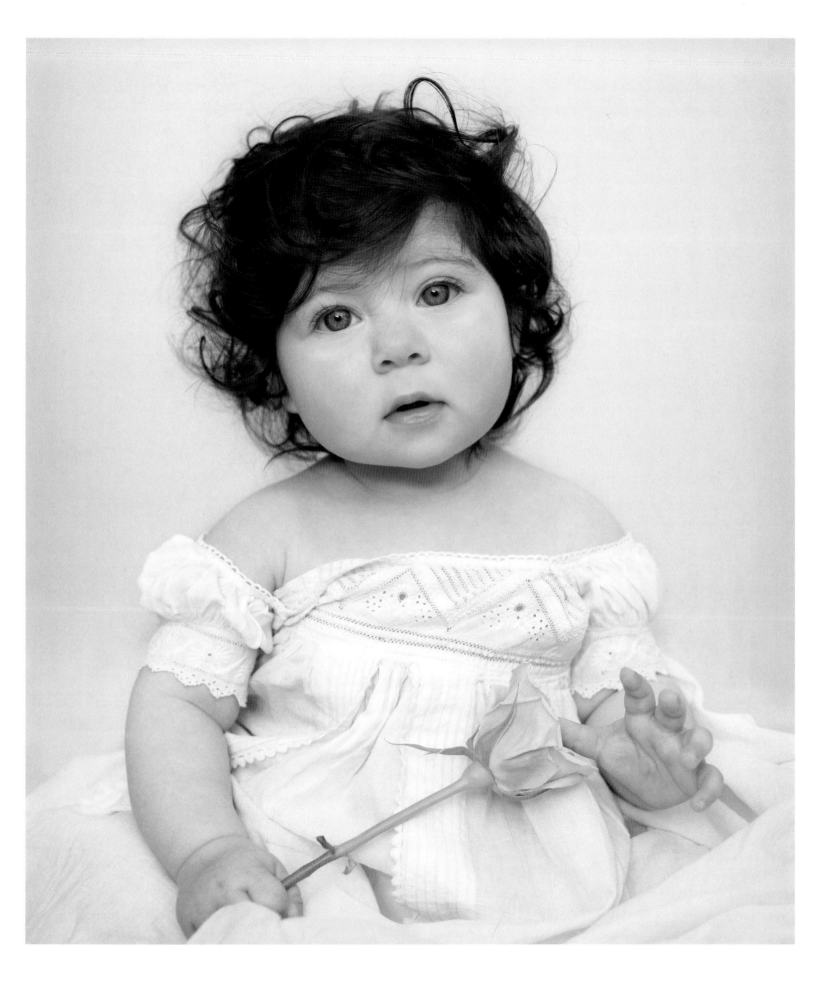

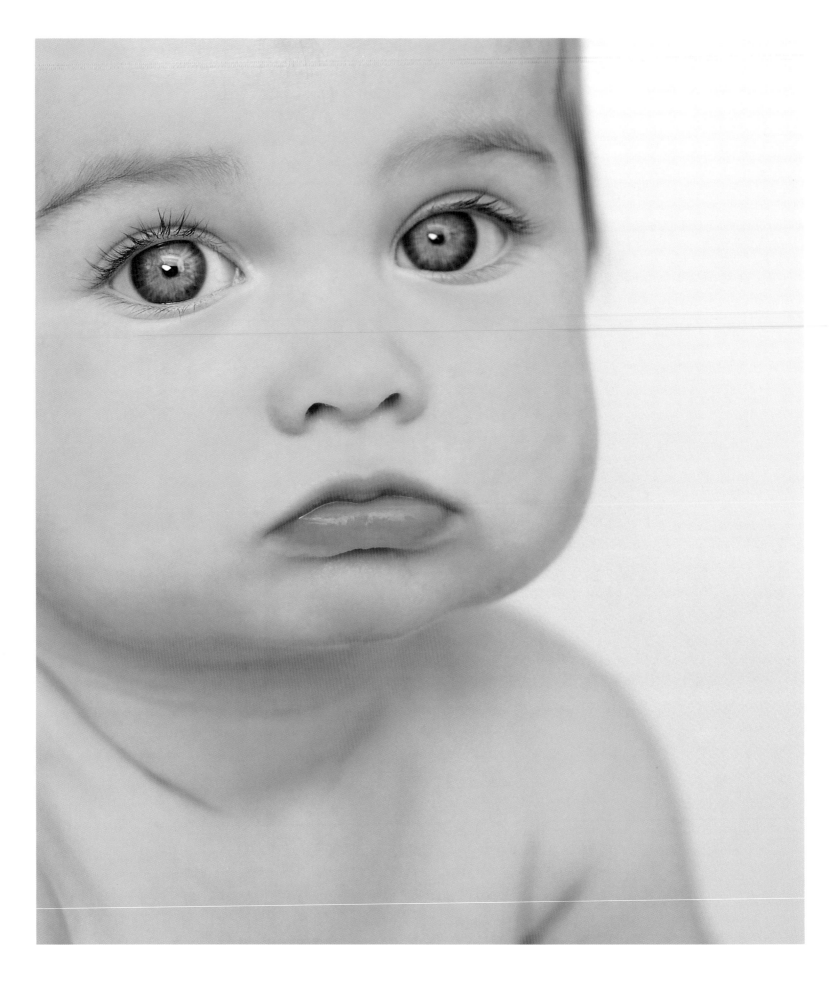

A child who cries long will live long.

EUROPEAN PROVERB

Baby expressions…

To wet the baby's head: To celebrate a baptism with a social gathering; to drink to the health of a newborn baby.

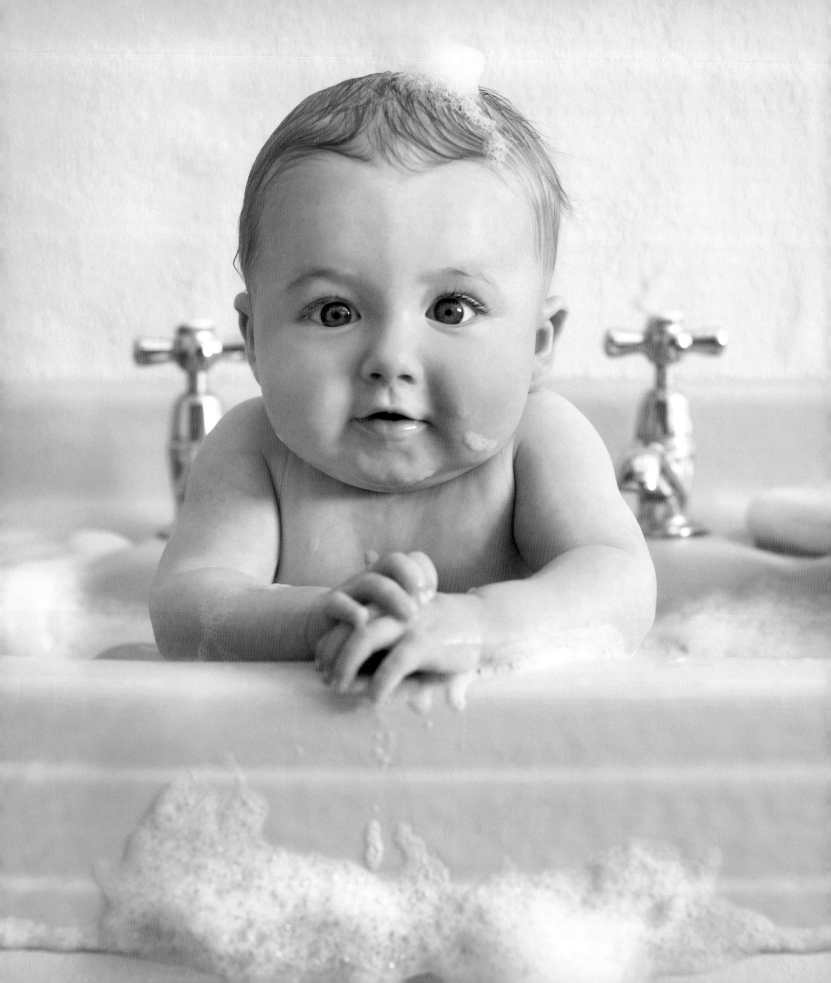

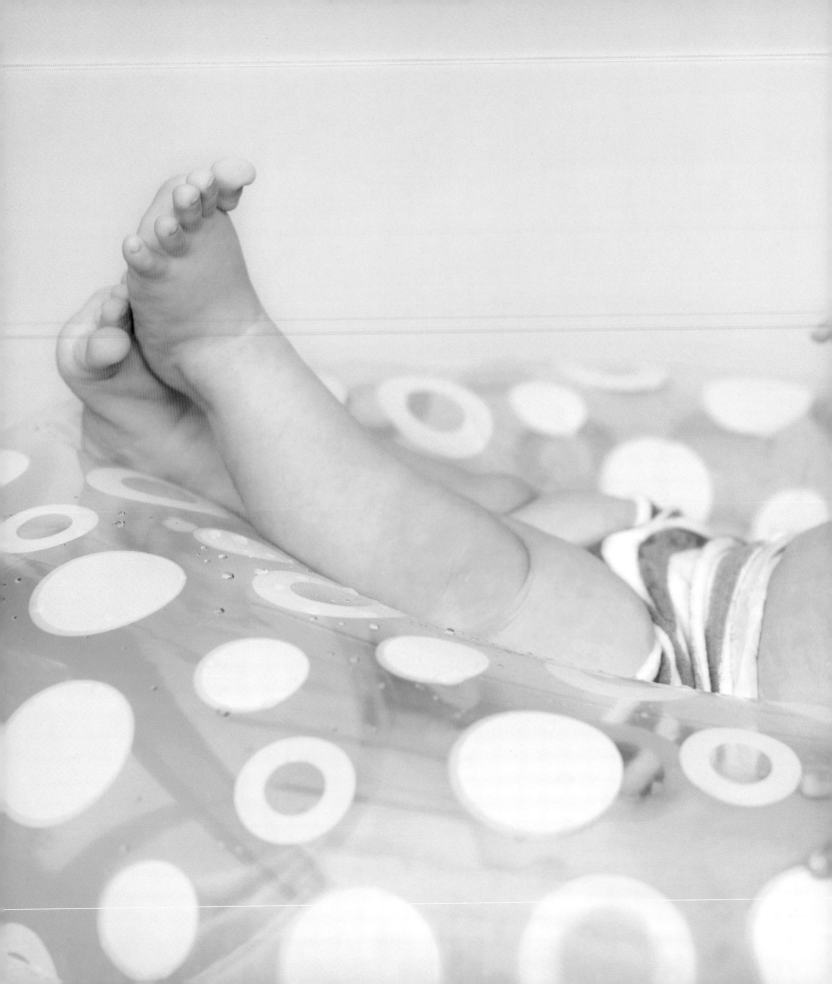

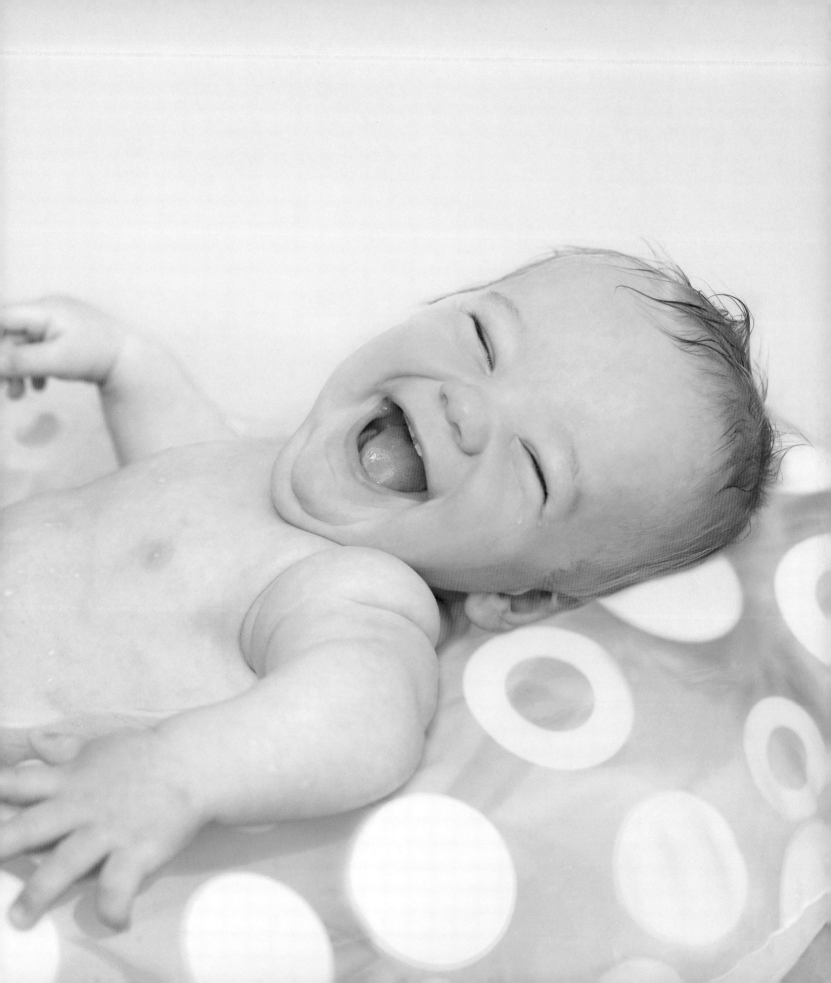

Names from Around
— *the World* —

Many African tribes have very rigid traditions for naming their children. Some tribes name the child after relatives using a specific and sometimes complicated order. Others name the child according to the place, time, or circumstances of birth.

After a baby is born in Thailand, parents often ask the family priest to choose the name. The priest takes into consideration the day of the week and the general characteristics of the child before making his selection.

Arabic names are often just special uses of ordinary words.

In Cuba, a child born by Caesarean section is often called Cesarina.

In some countries, names become popular after a significant historical event. For example, after the 1917 revolution in Russia, given names were often tied to communist or worker doctrine.

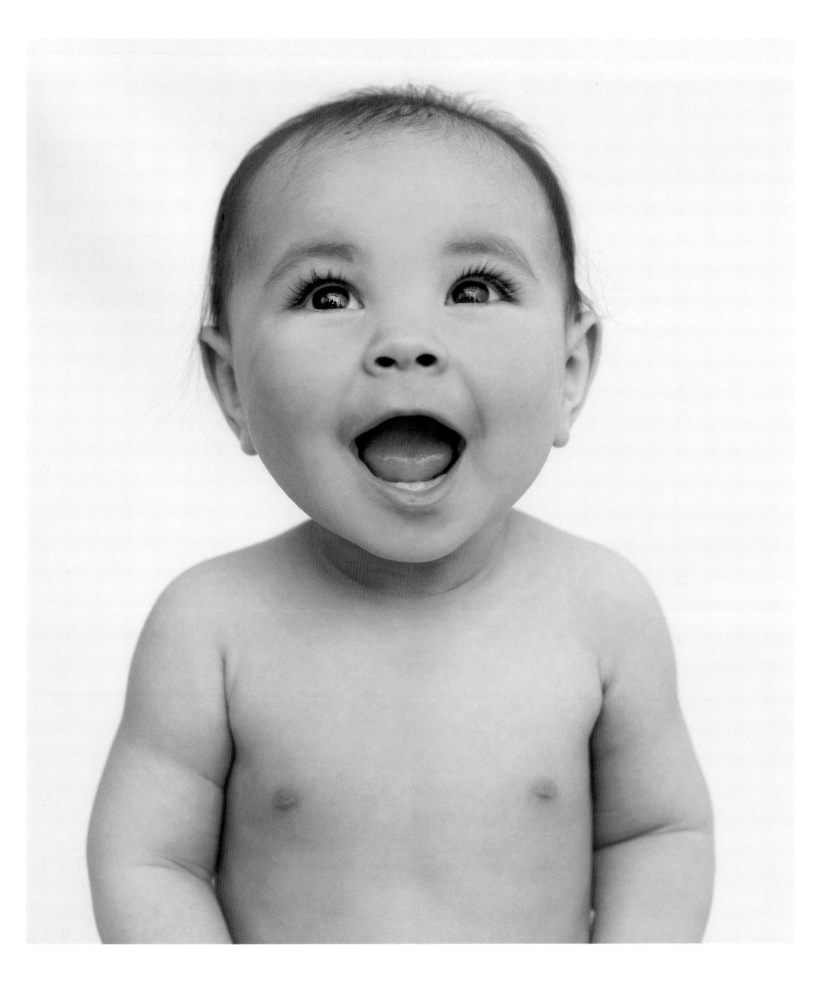

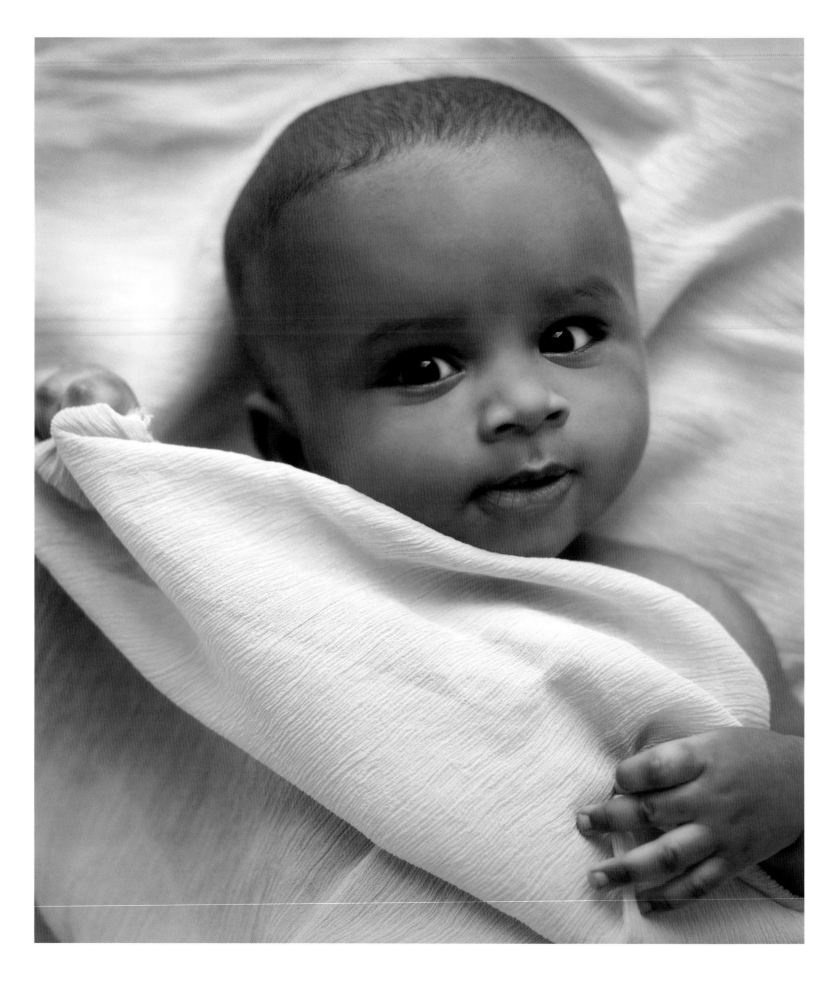

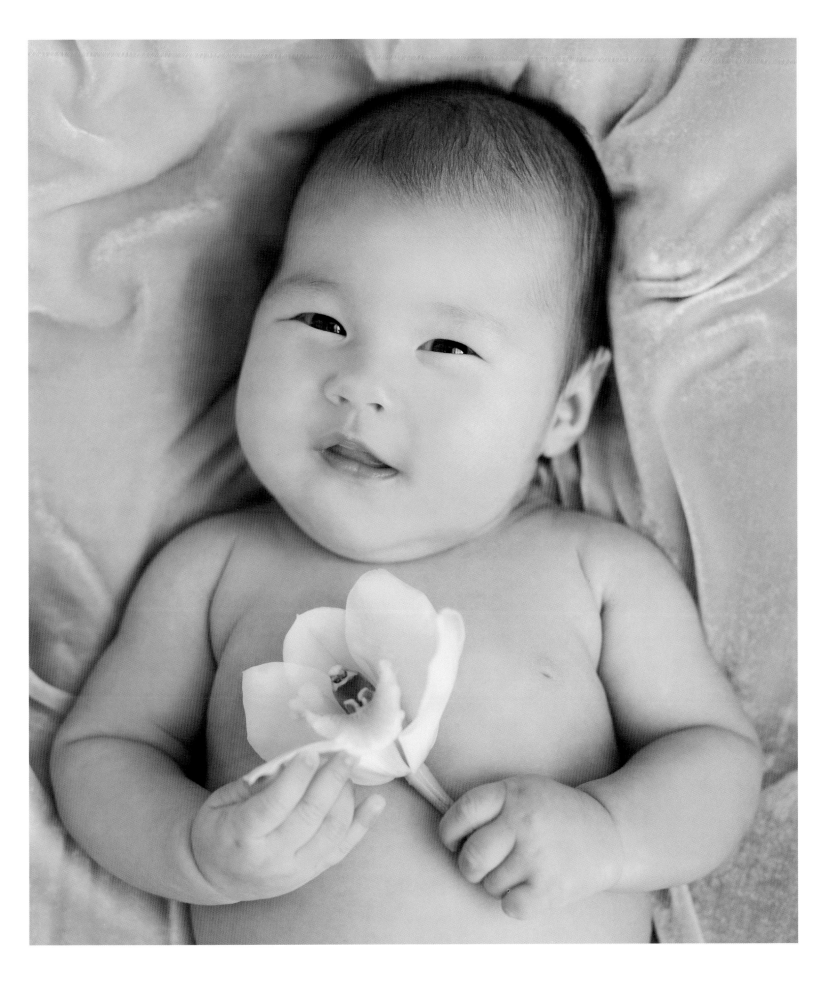

A baby

will make love stronger,

days shorter,

nights longer,

bankroll smaller,

home happier,

clothes shabbier,

the past forgotten,

and the future

worth living for.

ANONYMOUS

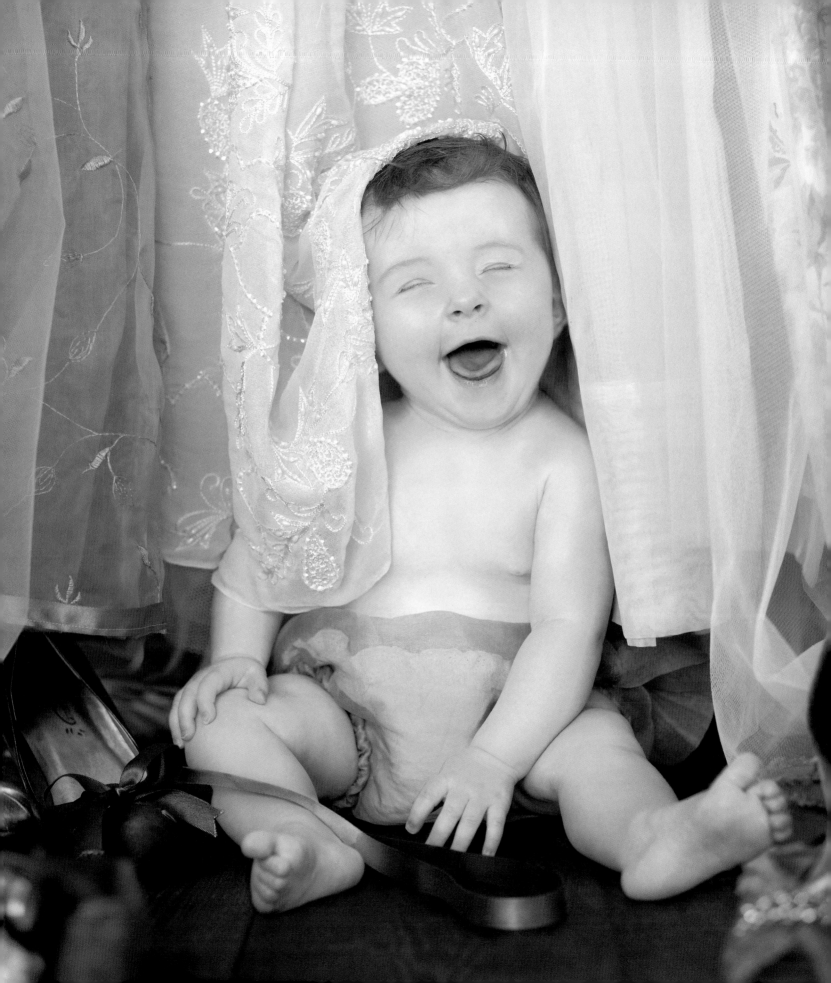

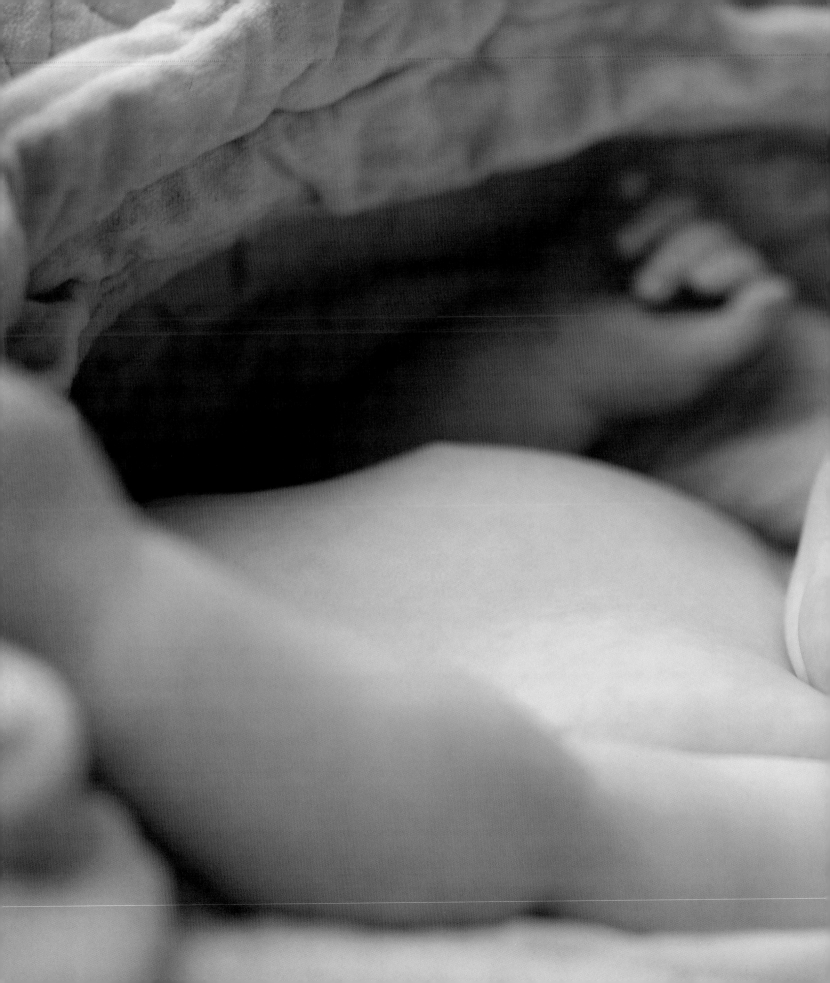

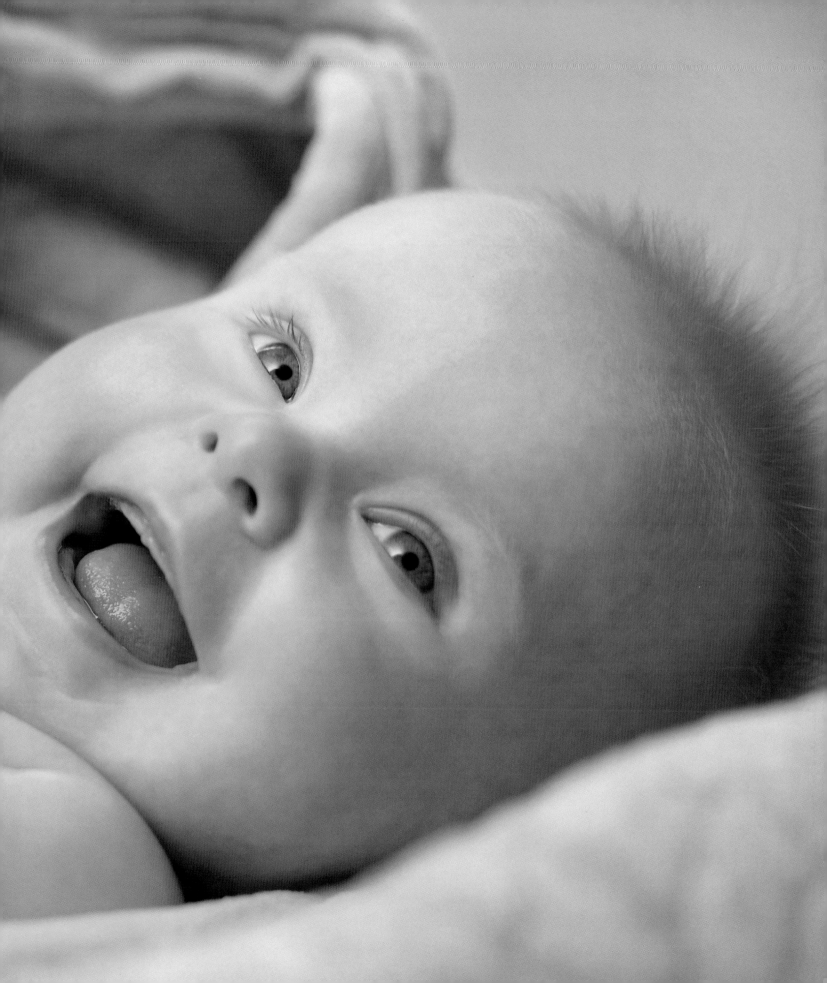

Bath Time

Swimming Lessons: Support your baby on his back and gently pull him along the length of the bath, then do the same on his front.

✳

Toy Time: The action of reaching out to float toys in front of your baby is his first step toward a swimming arm movement.

✳

Splish Splash: Splash your hands gently on the surface of the water and watch your baby do the same.

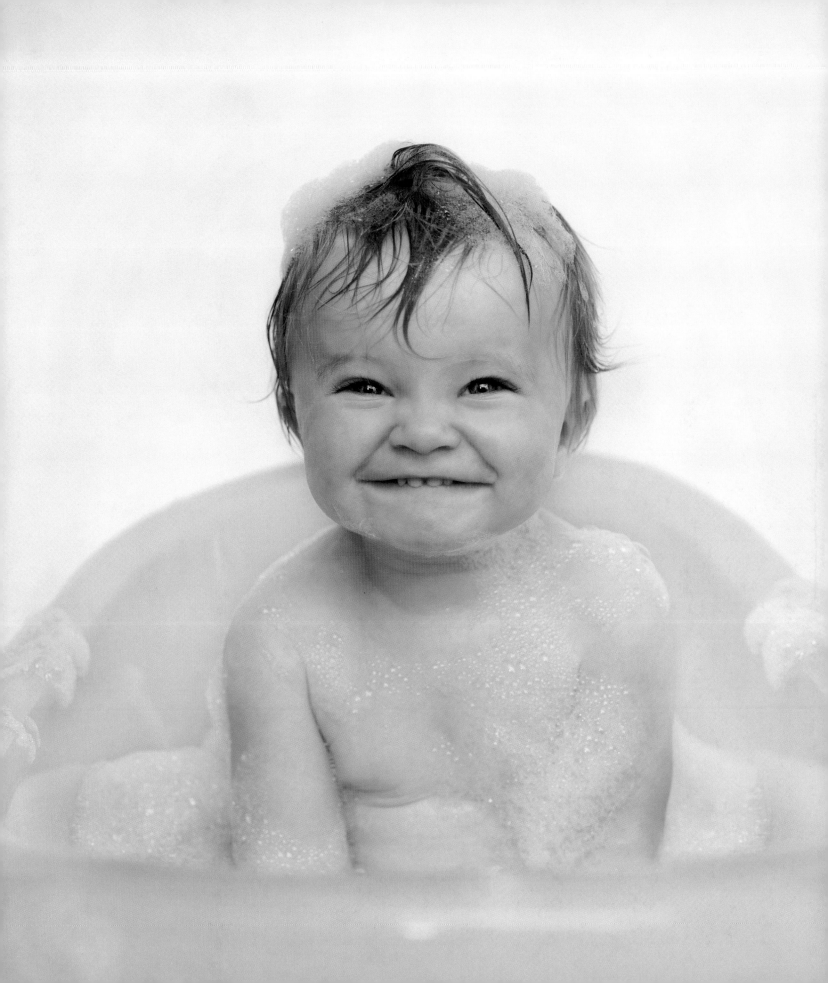

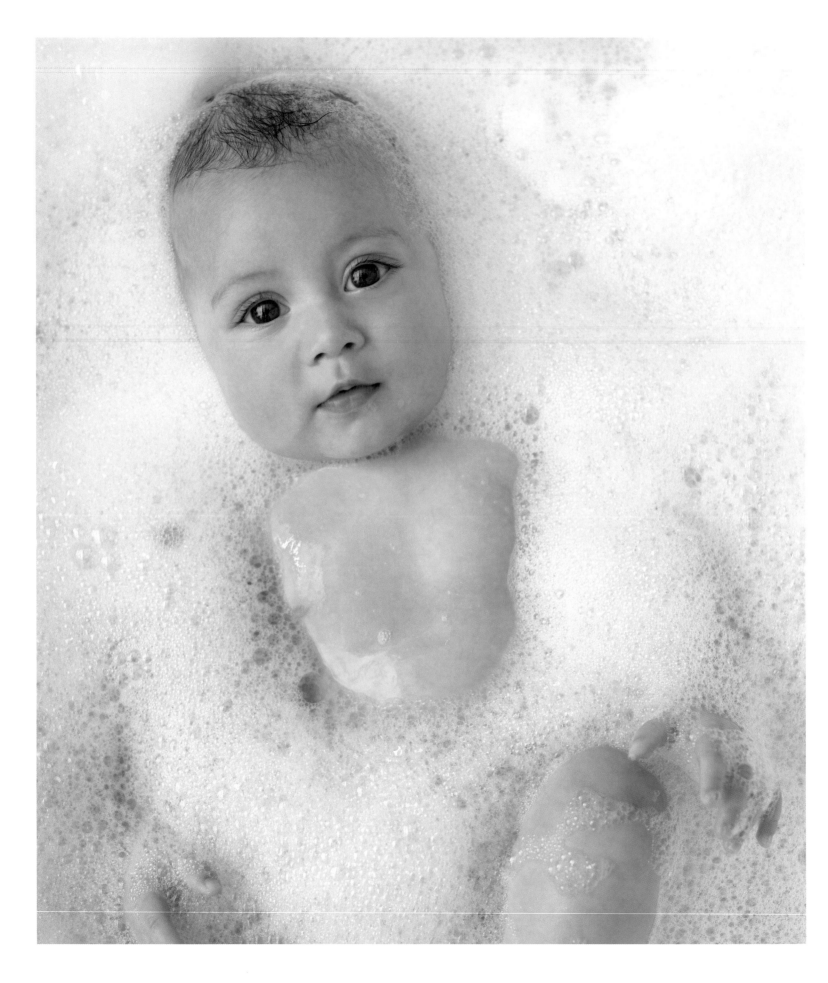

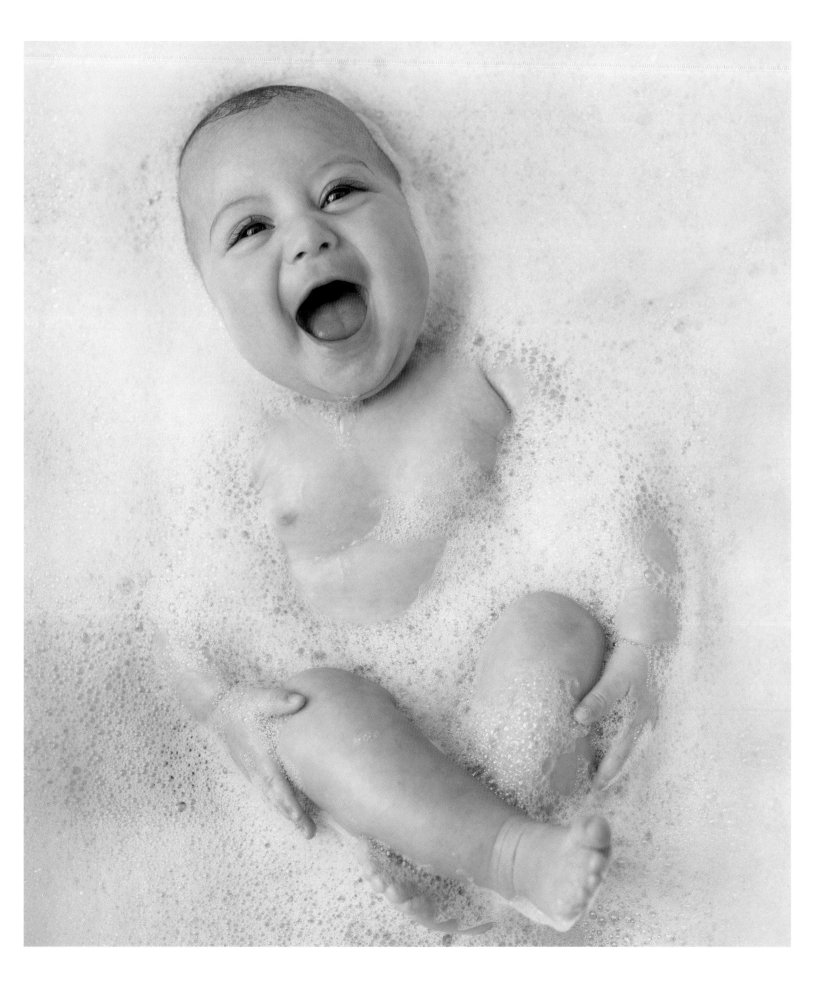

Baby expressions...

To throw the baby out with the bath water: To reform or alter something so radically or indiscriminately that the essentials are lost.

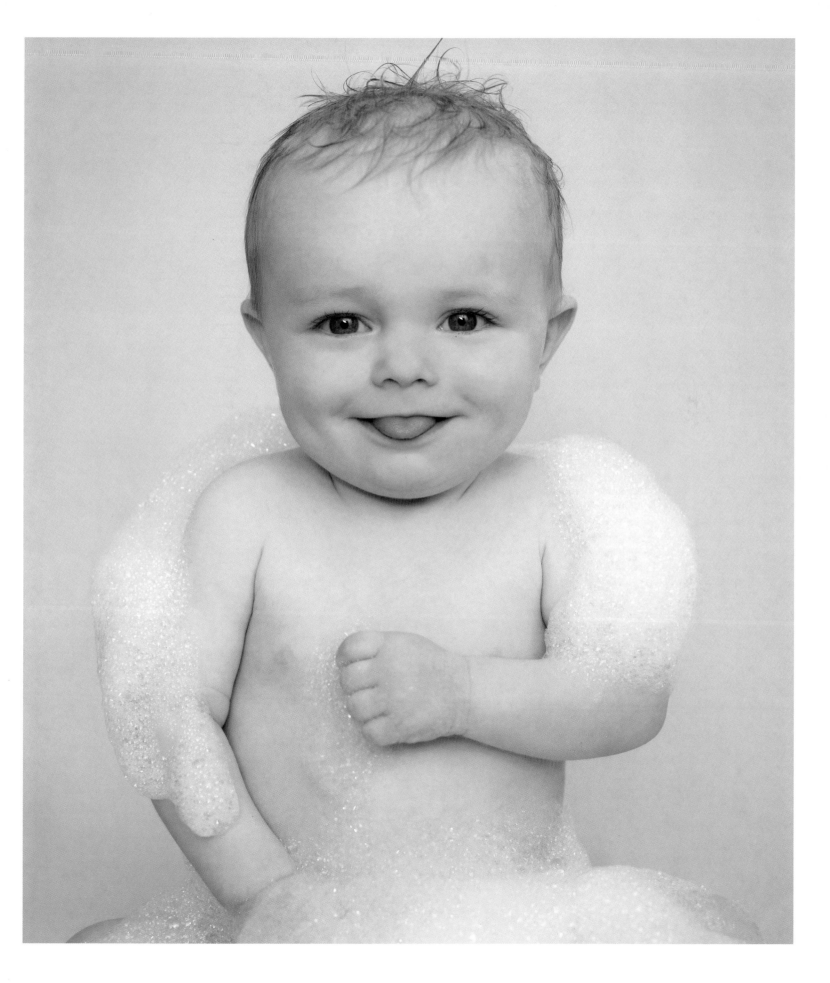

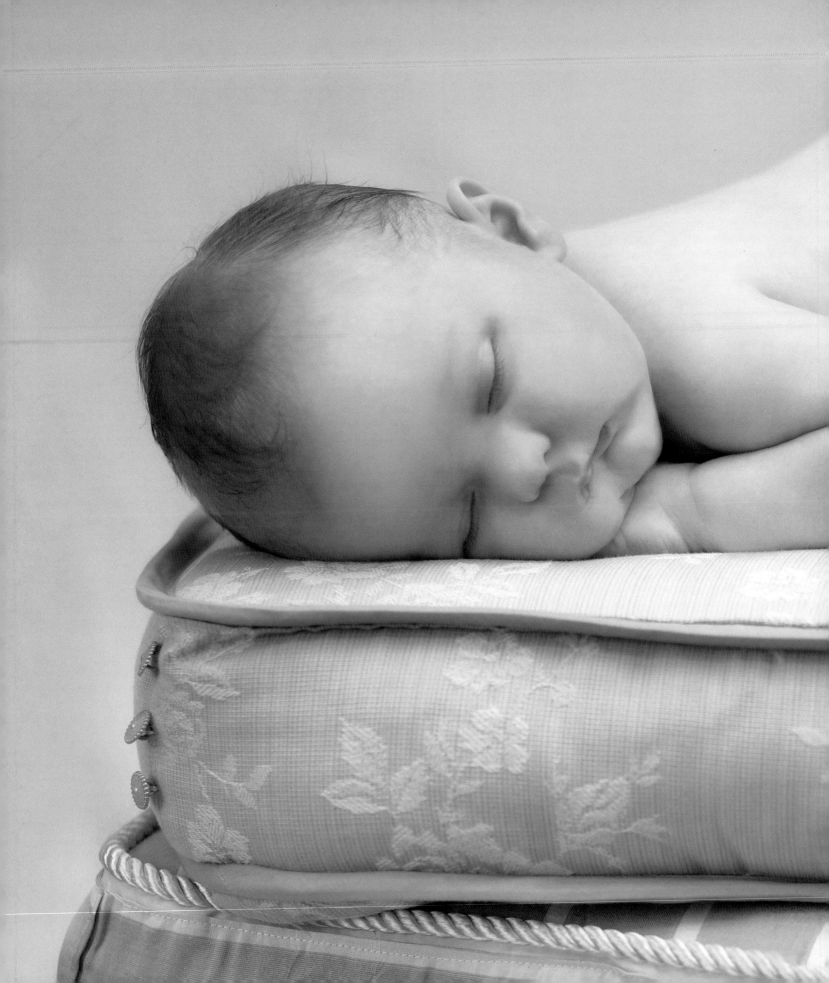

Famous Fairy Tales

The Princess and the Pea

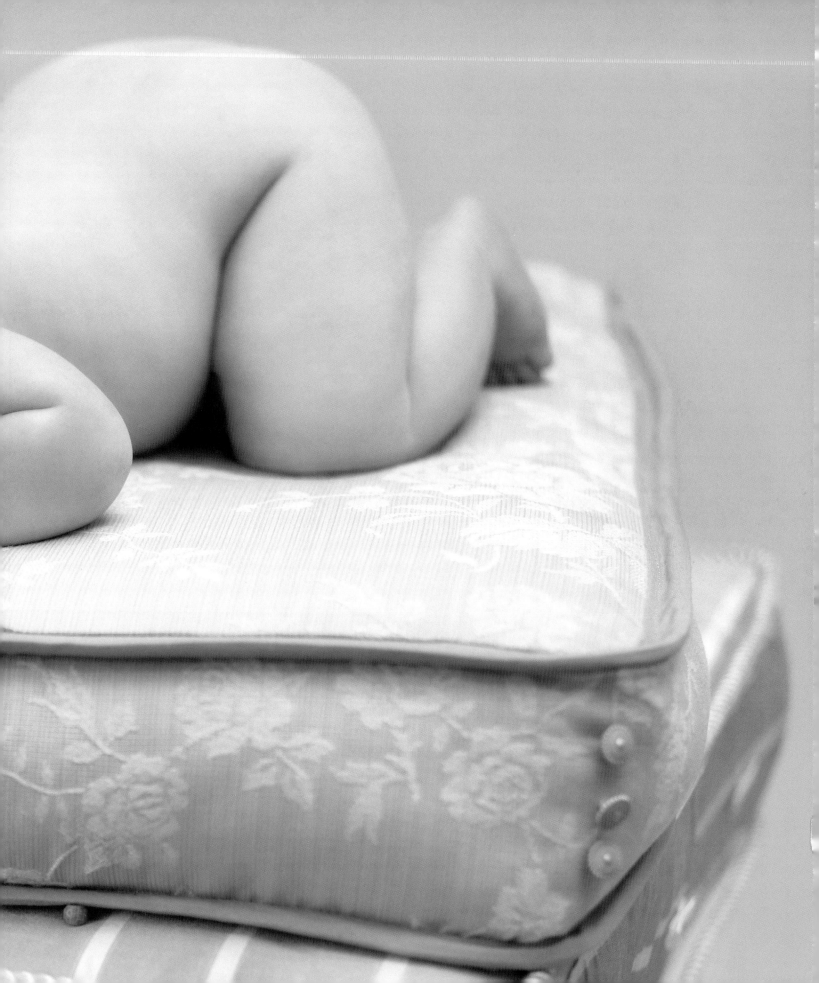

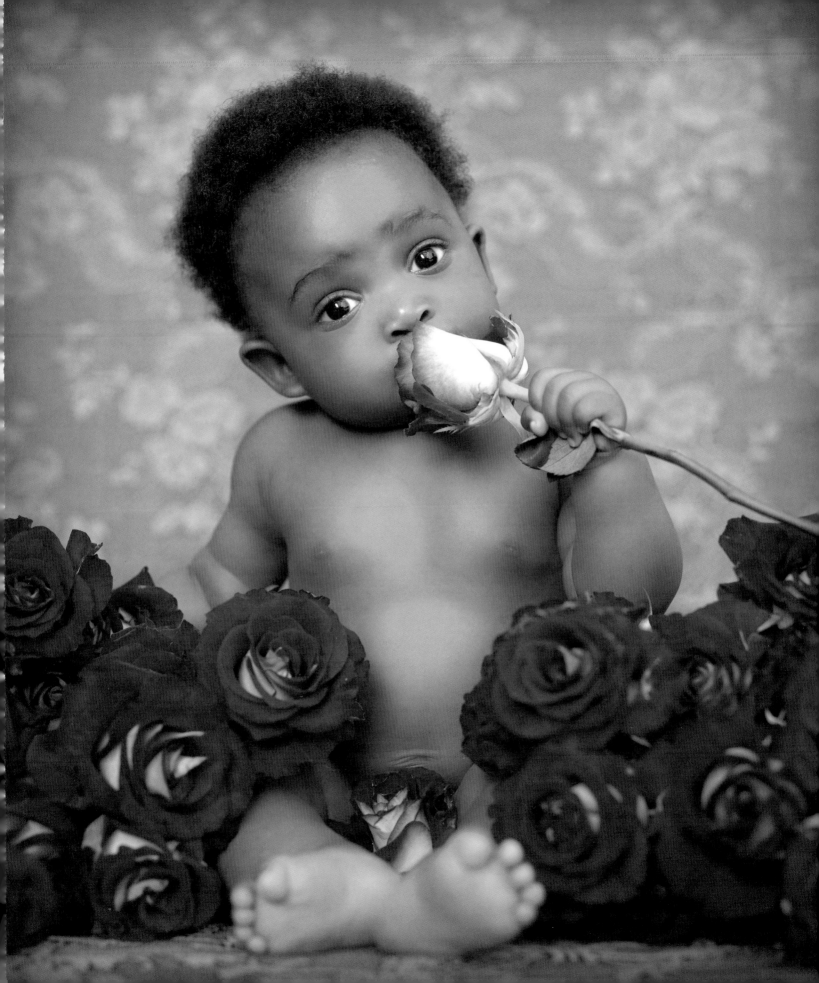

Ring Around the Rosies

Ring around the rosies,

A pocket full of posies,

Ashes, ashes.

We all fall down!

Mummy in the teapot,

Daddy in the cup,

Baby in the saucer,

We all jump up.

Ring around the rosies,

A pocket full of posies,

Ashes, ashes.

We all fall down!

The cows are in the meadow,

Eating buttercups,

Ashes, ashes.

We all jump up.

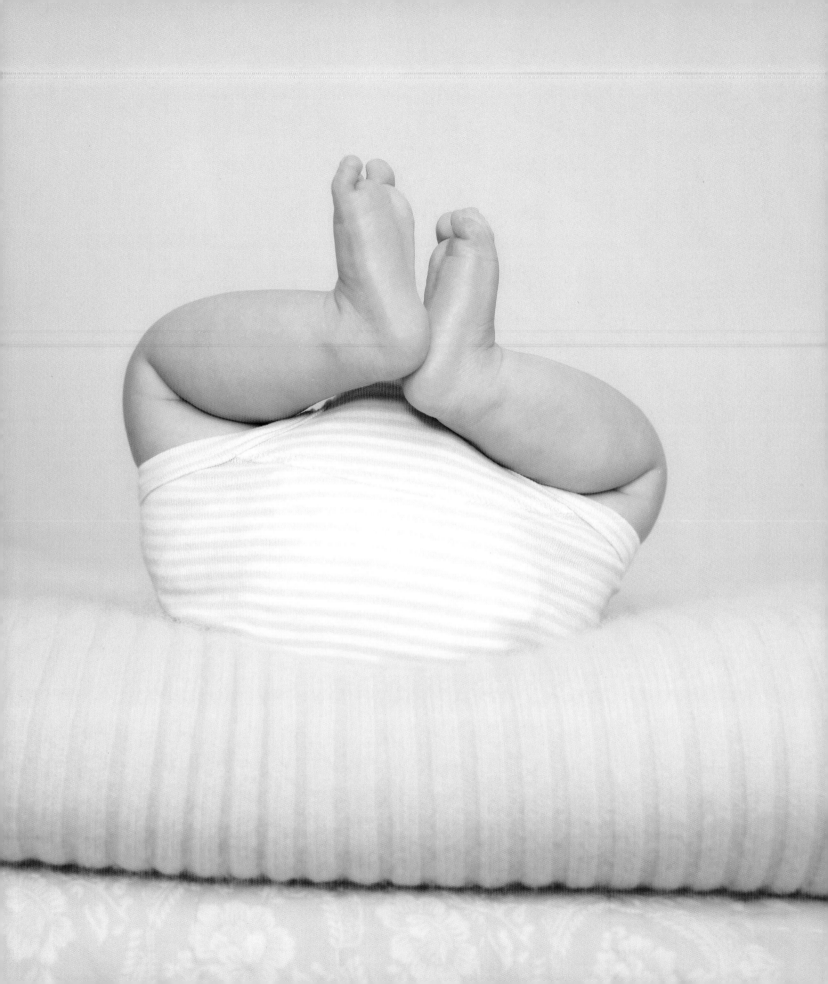

Little Piggy

"This little piggy went to market, this little piggy stayed at home.

This little piggy had roast beef, this little piggy had none.

And this little piggy cried 'Wee, wee, wee!' all the way home."

There is no finer investment for any

community than putting milk into babies.

WINSTON CHURCHILL

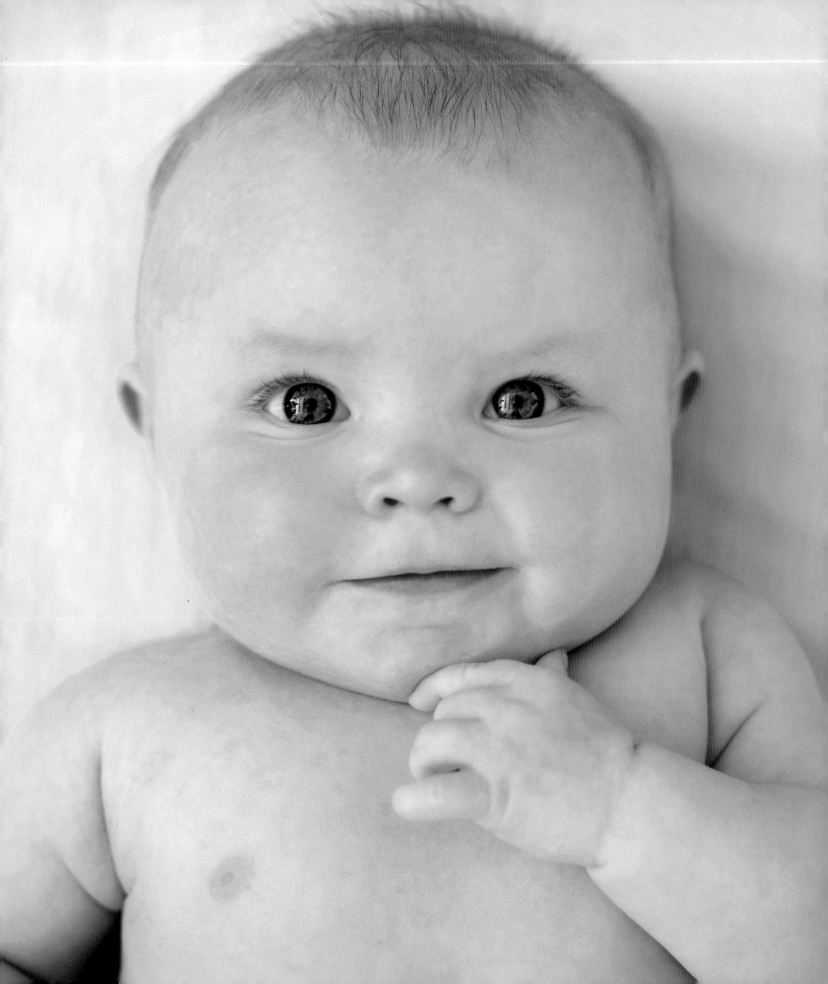

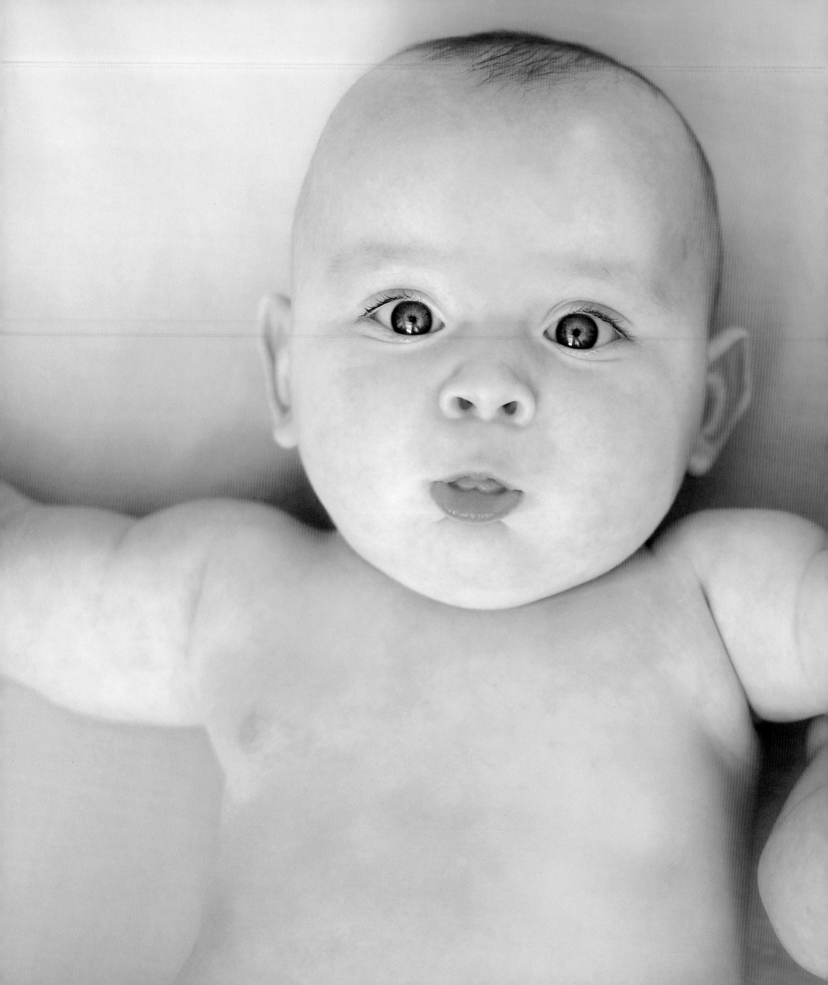

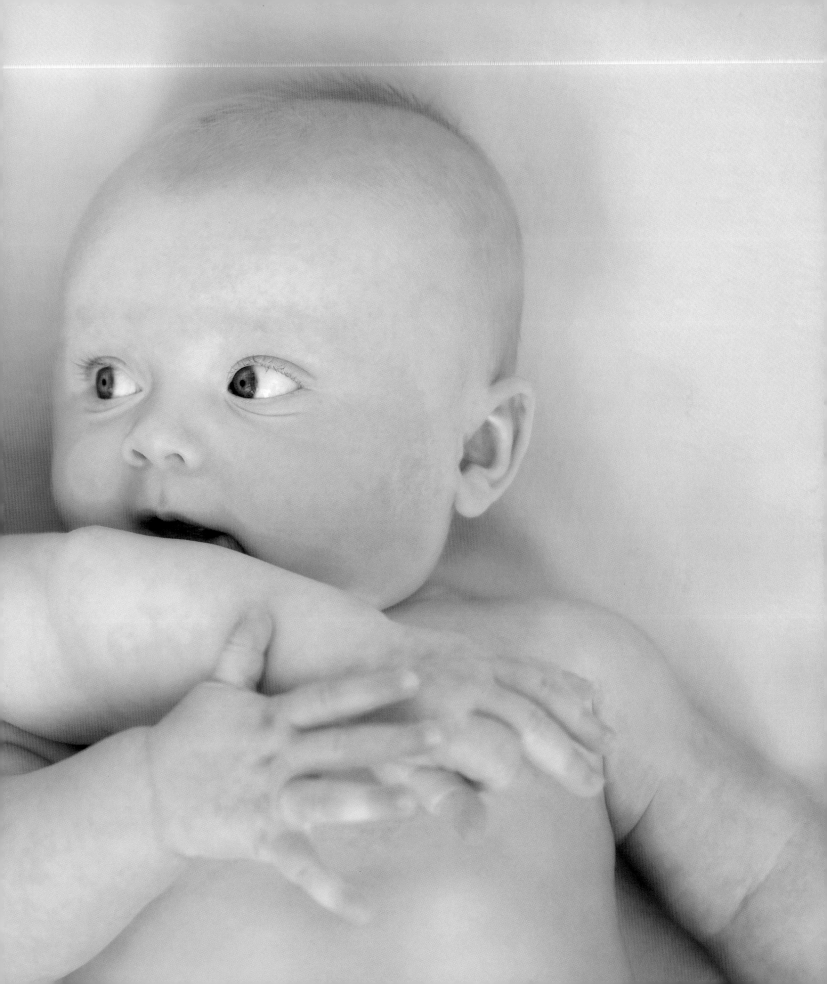

Babies are always more trouble than you thought...

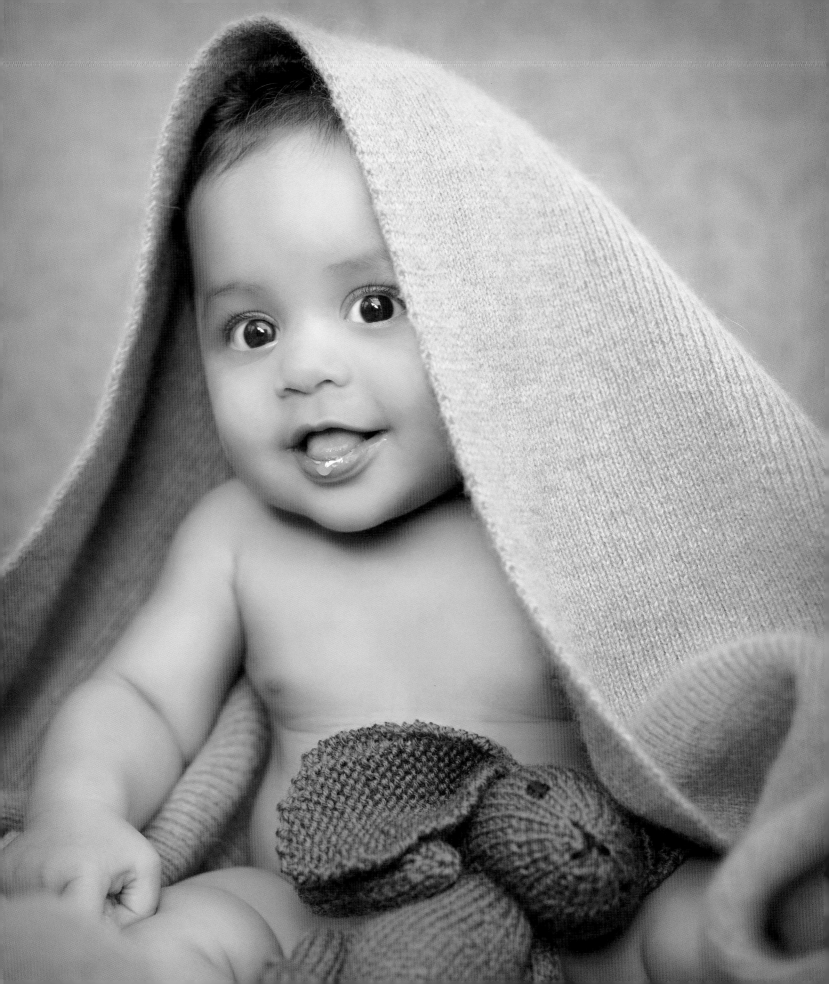

and more wonderful.

CHARLES OSGOOD

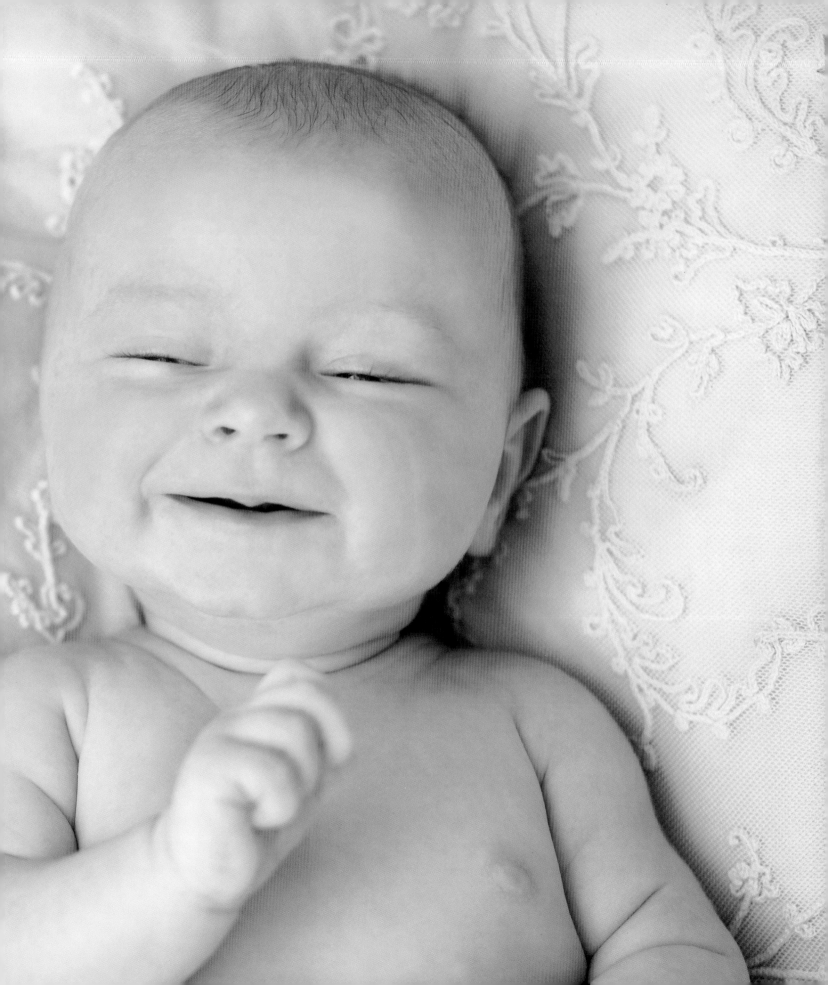

Baby expressions...

Baby blues: Human eyes, irrespective of their actual color. Baby blue is a light shade of blue, often associated with a baby's eyes; the implication is of candor and innocence.

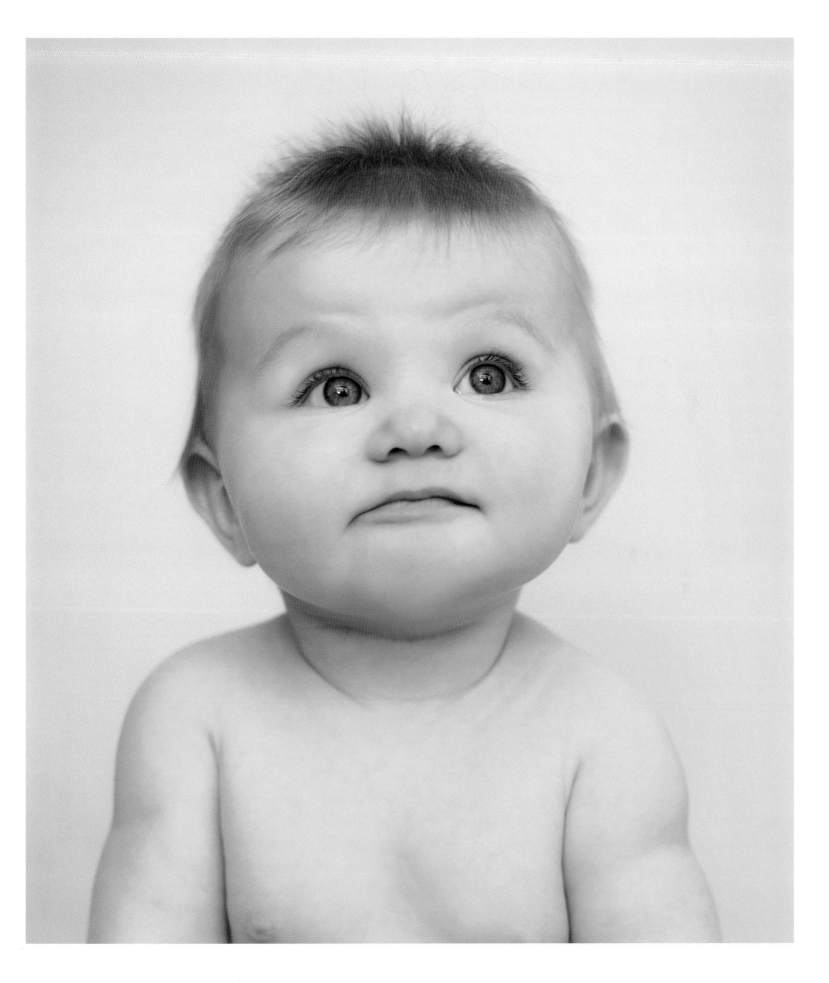

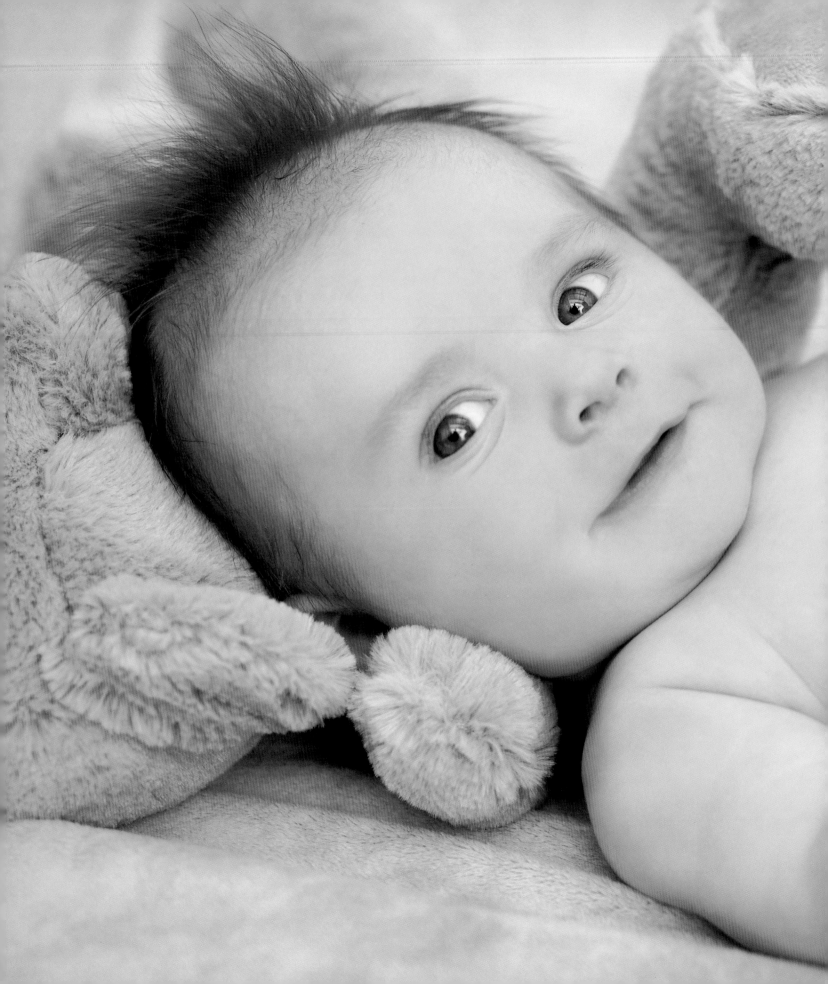

Interesting facts about twins

The scientific study of twins is known as "gemellology."

The word "twin" is probably derived from an ancient German word "twine," which means "two together."

Fraternal twins are much more common than identical twins. The chance of having identical twins is about one in 285.

Interesting facts about multiples

Worldwide there are at least 125 million living multiples.

The United States has one of the highest rates of multiples, while Japan has one of the lowest with multiple births occurring in one in 120 births.

The average weight of a singleton newborn is 7 lbs 6 oz, but the average weight of a triplet newborn is 3 lbs 12 oz.

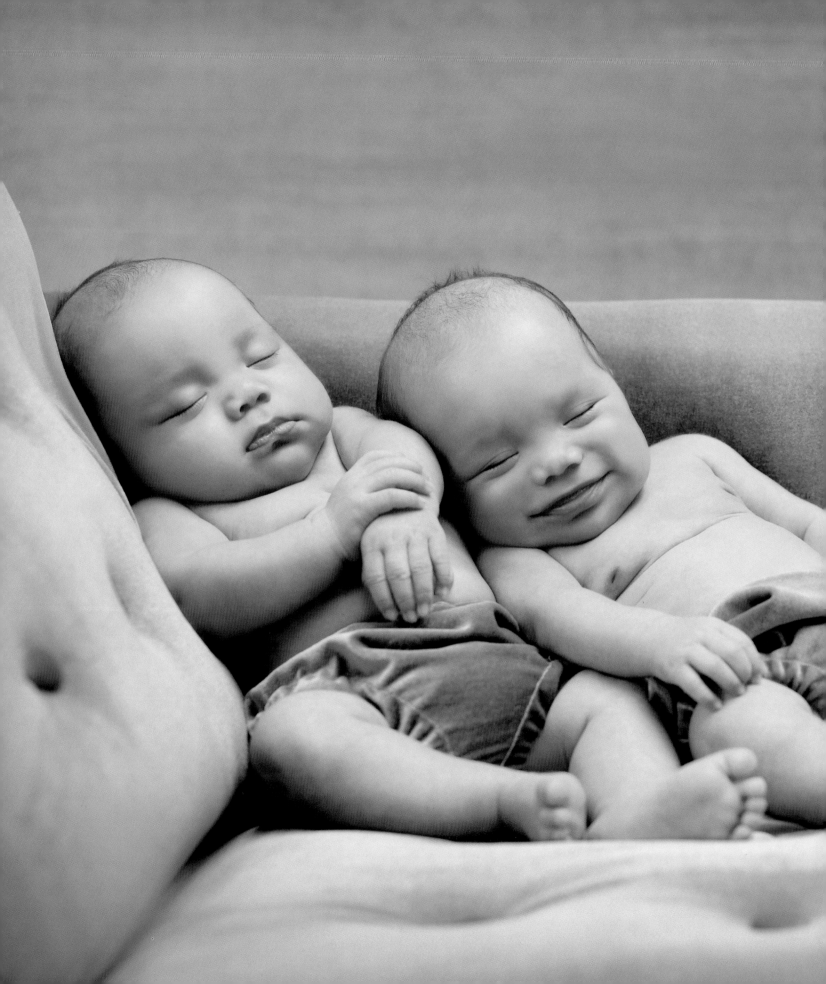

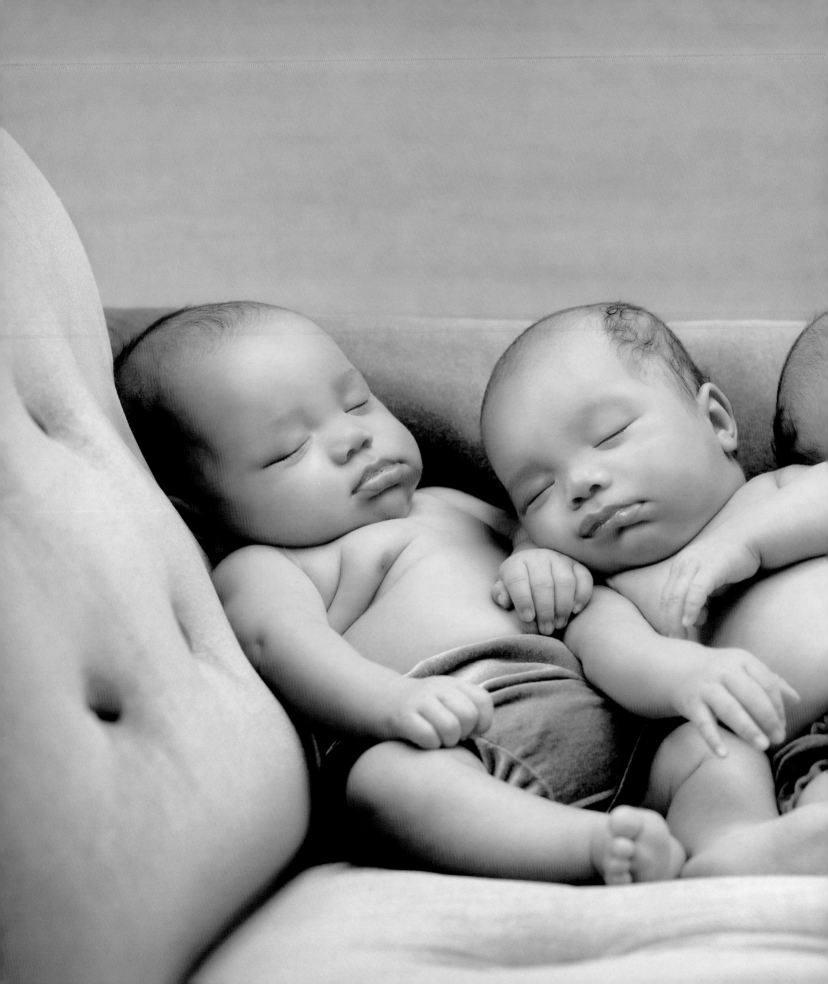

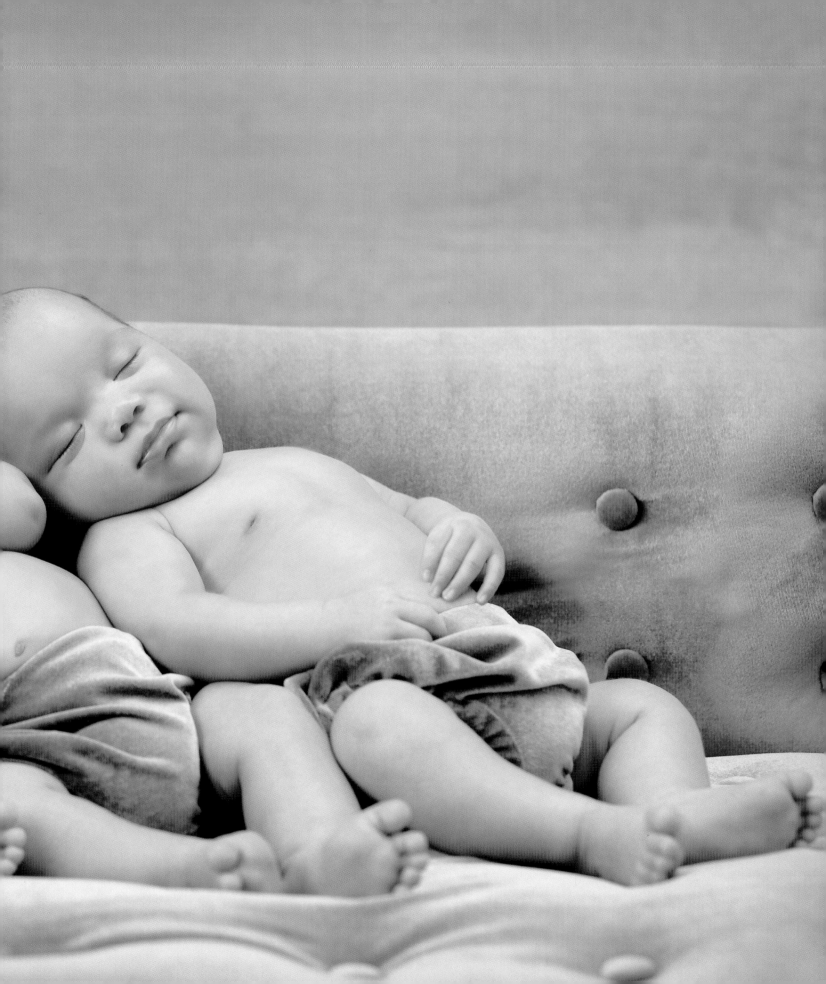

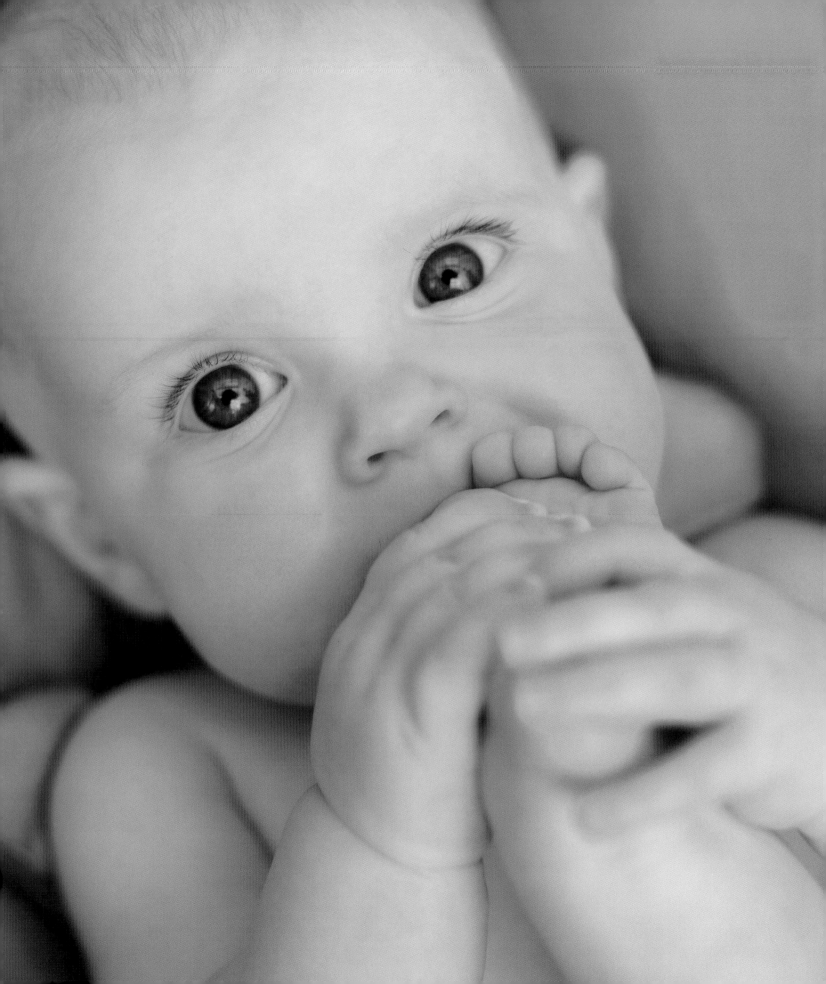

Patience is a virtue,

Virtue is a grace;

Both put together...

make a very pretty face.

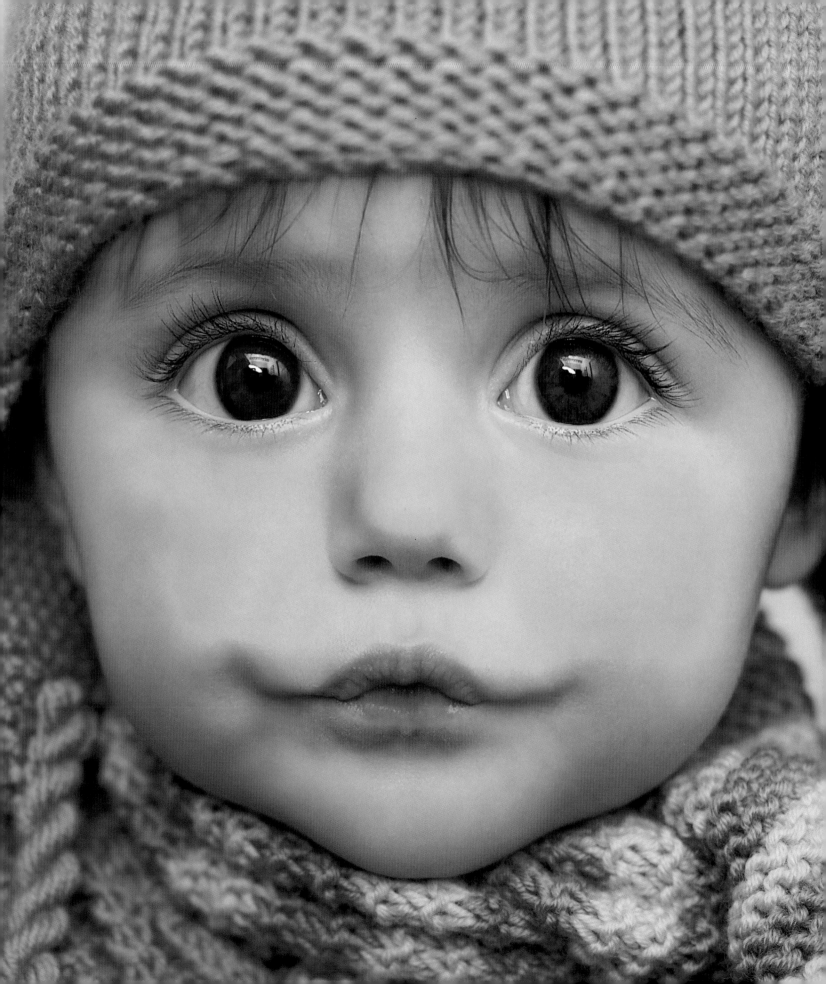

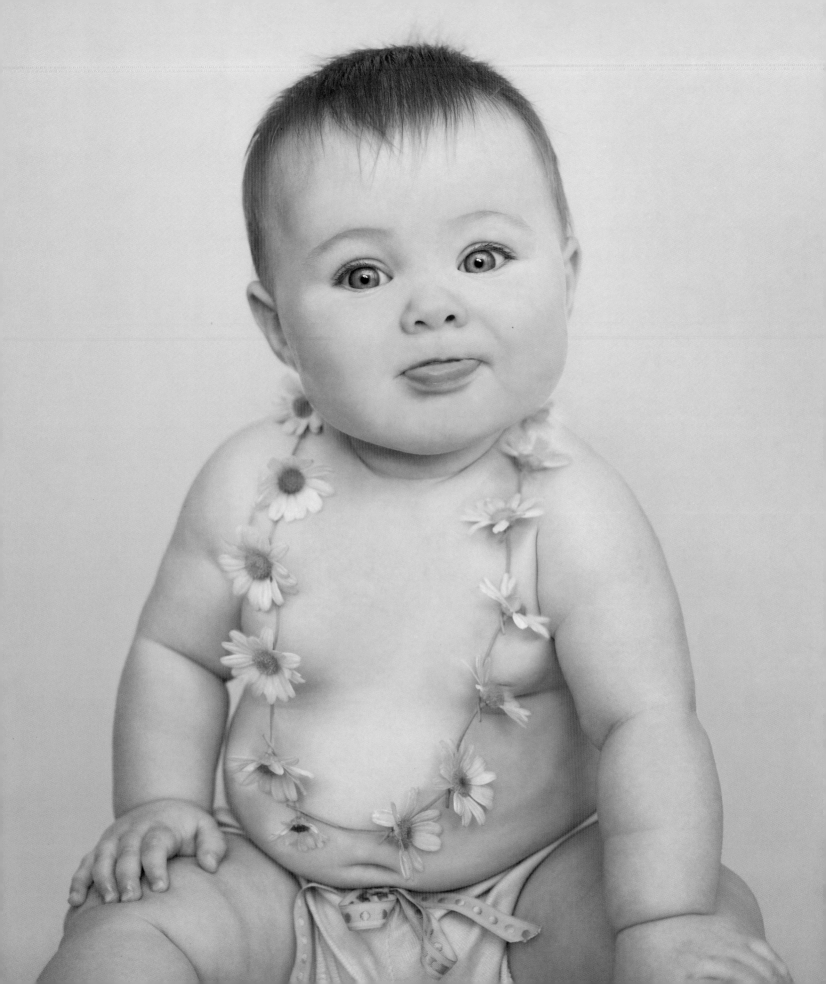

─── *Pink & Blue* ───

Accepted baby colors are blue for boys and pink for girls.

The reasons for the choice of color date back to the ancient preference for baby boys. Blue, the color of the heavens, was selected for dressing male infants to give them the best possible protection from the evil eye.

To differentiate their girls, European mothers chose pink, the color of the European baby's skin, thus emphasizing the girl-child's overall human (rather than heavenly) appeal.

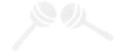

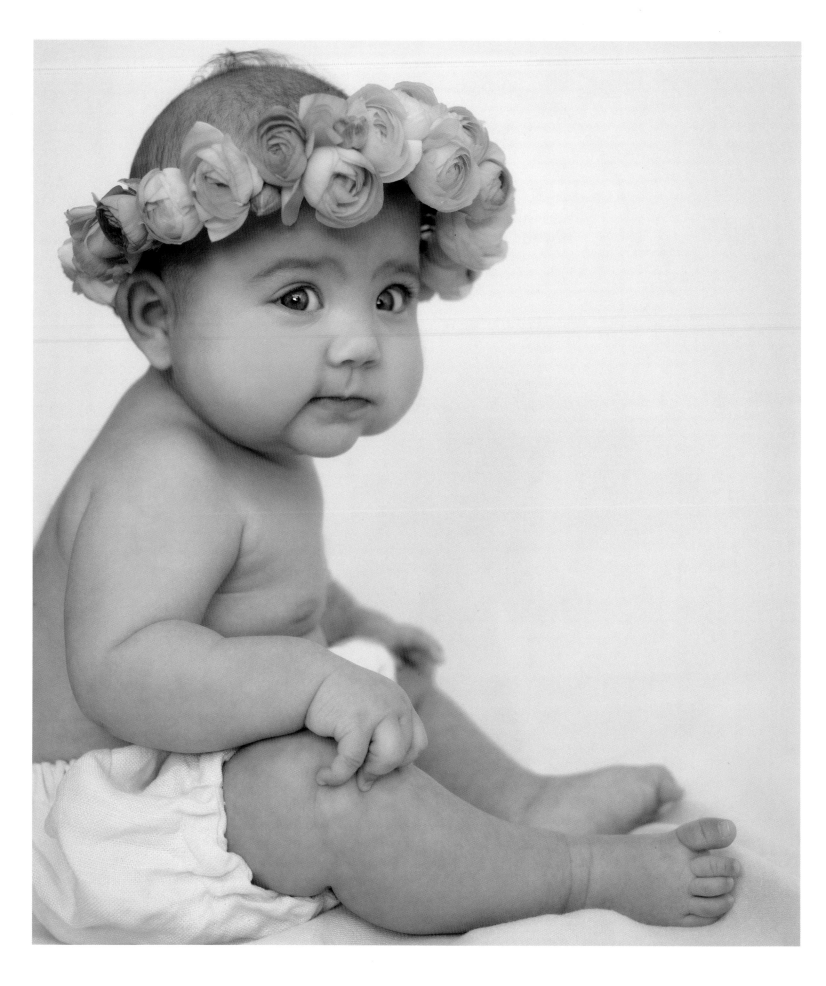

What are little girls made of?

Sugar and spice and all things nice.

What are little boys made of?

 Snips and snails, and puppy dogs' tails.

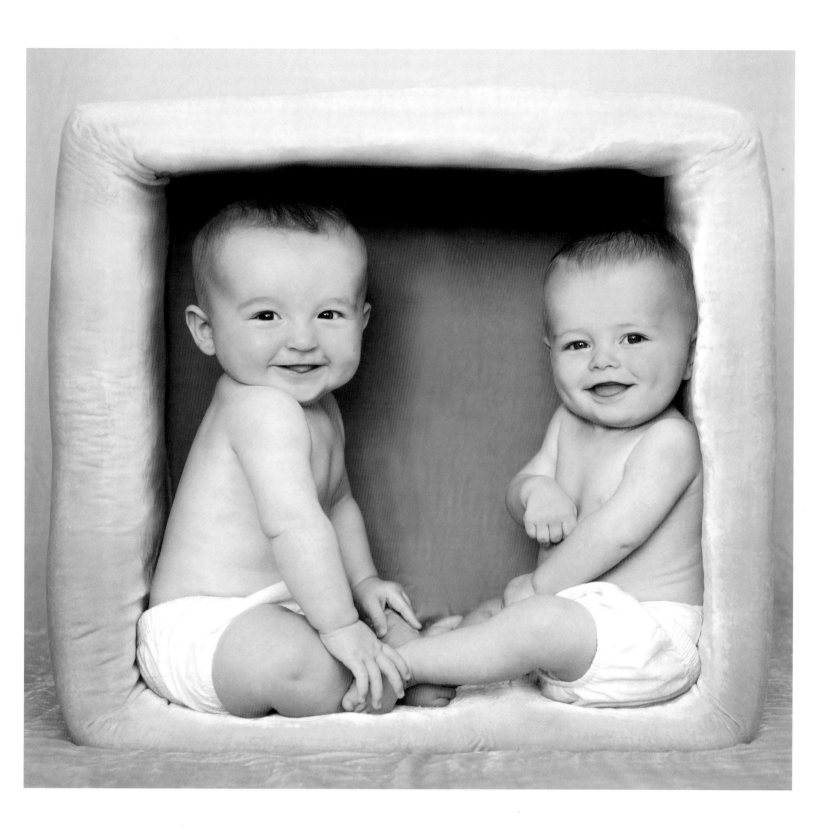

Special Delivery

The most traditional form of carrying device for a baby is a basket,
made famous by Moses in the biblical bulrushes.

✳

Seri babies of New Mexico are carried in a shallow basket filled with sand
and lined with a cloth.

✳

The ancient Anasazi people of the Four Corners—the point where Utah,
Colorado, New Mexico, and Arizona meet—carried their babies in baskets
made of oval willow rings, tied together with strips of juniper and bound
with soft deerskin.

✳

In Siberia, the Mansi baby is carried in a tiny birch bark carrying cradle, and
kept warm under a soft swan-skin coverlet. Birch bark was used for centuries
in basket making throughout the Northern Hemisphere.

✳

A Chinese mother working in the rice fields carries her baby in a deep
wicker basket, held on by shoulder straps.

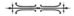

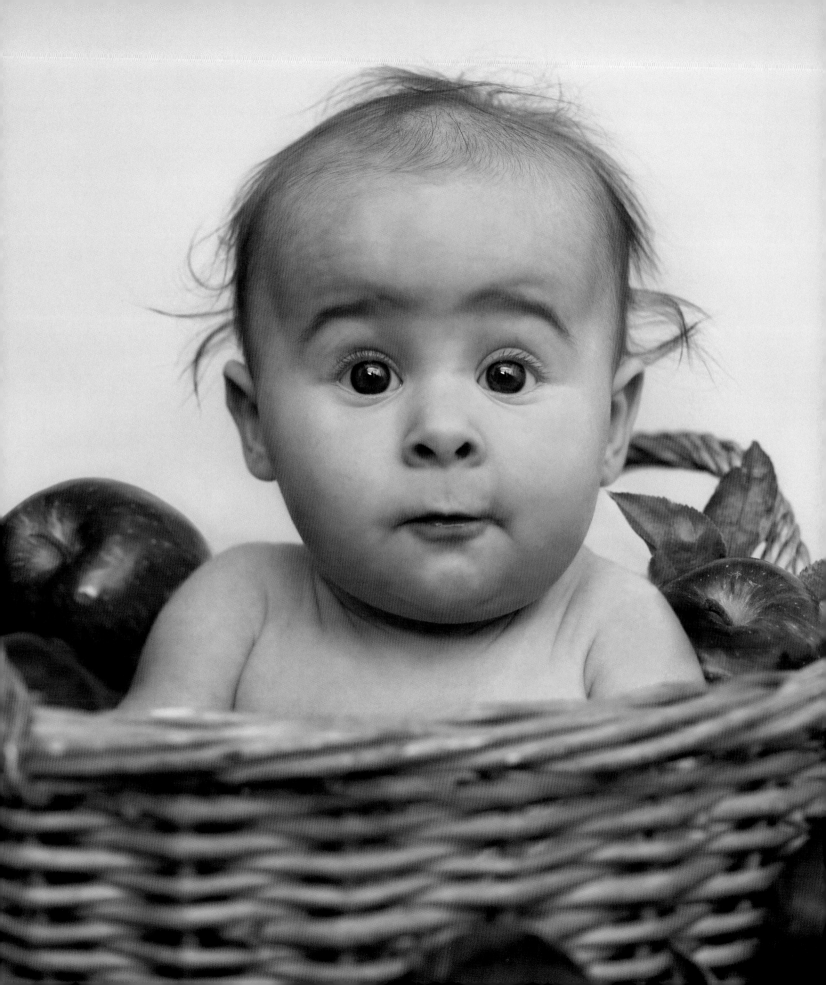

Yawning

In ancient times, babies who yawned too much
were thought to be at risk of letting their souls escape.
Roman mothers were advised to cover their babys' mouths,
a gesture that has remained in the European repertoire
of good manners for many centuries.

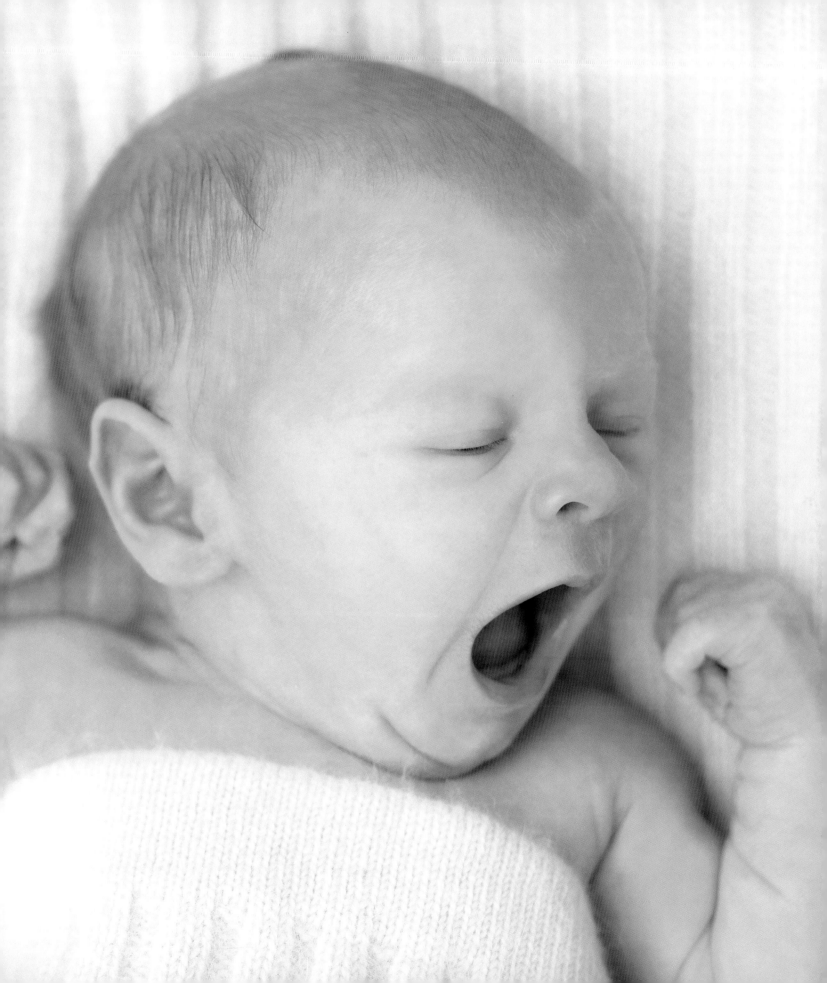

Pretty joy!
Sweet joy, but two days old.
Sweet joy I call thee.
Thou dost smile,
I sing the while,
Sweet joy befall thee!

WILLIAM BLAKE

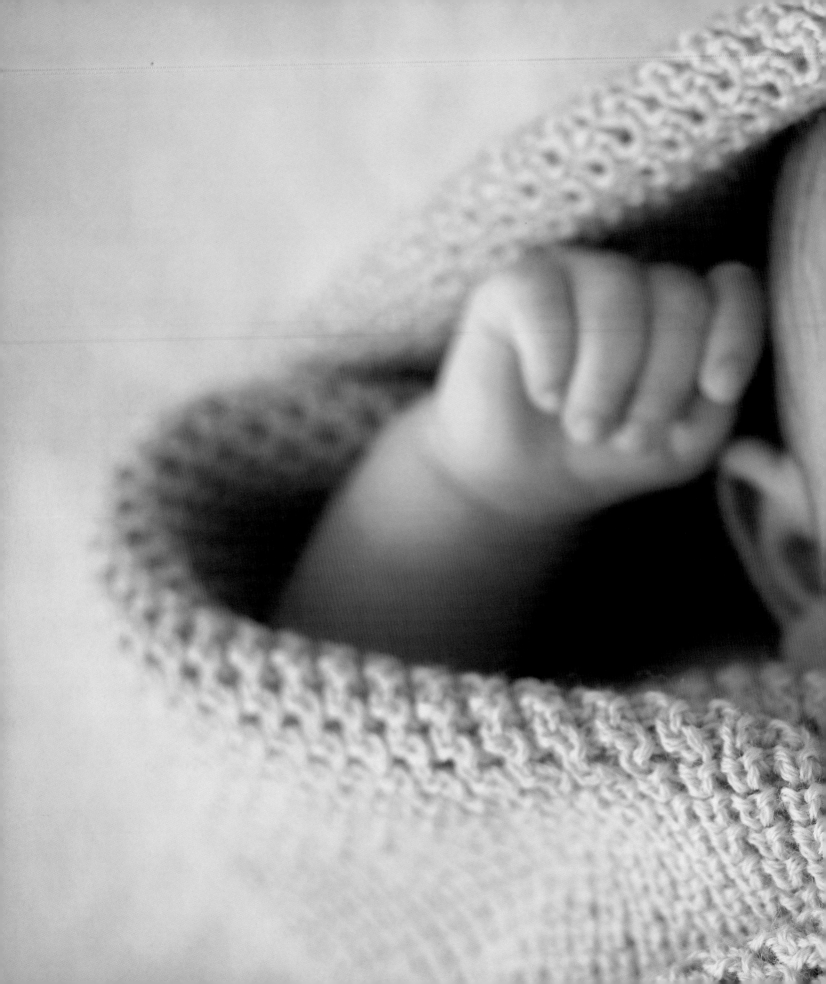

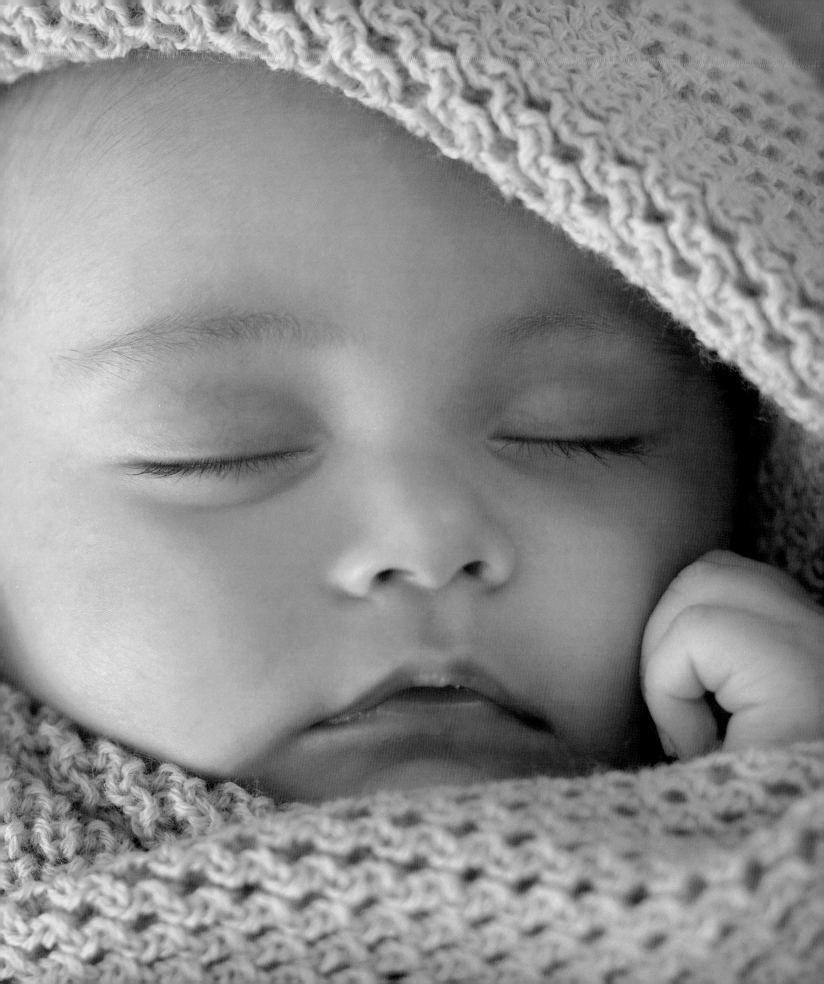

A perfect example of minority rule is a baby in the house.

ANONYMOUS

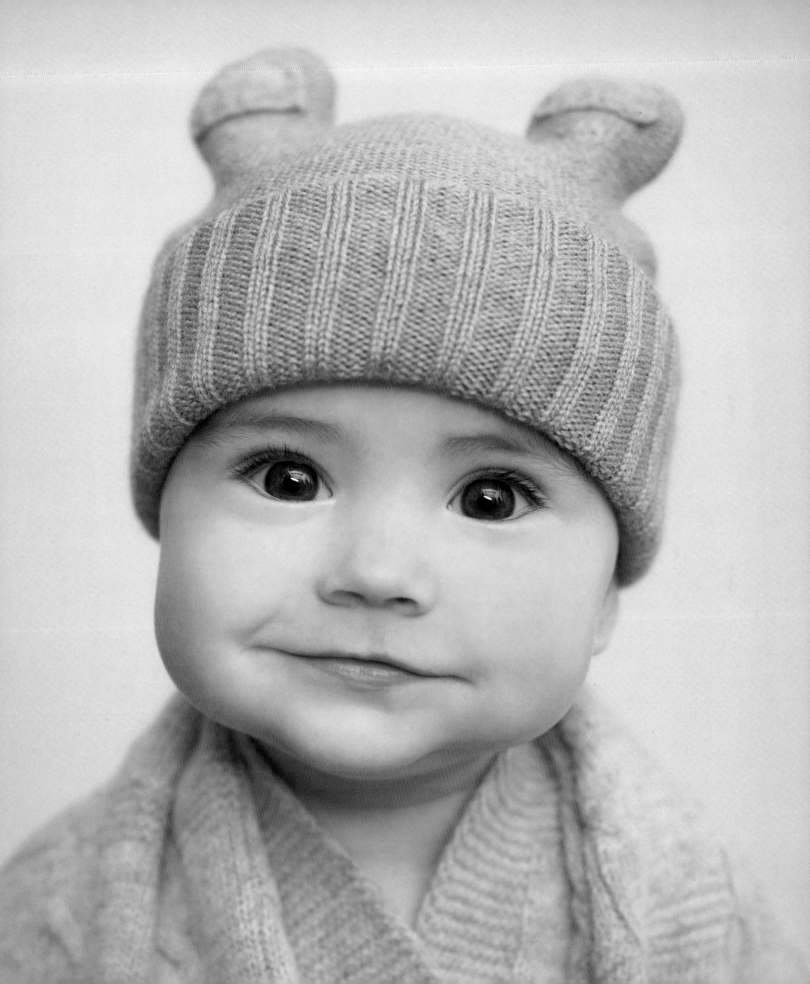

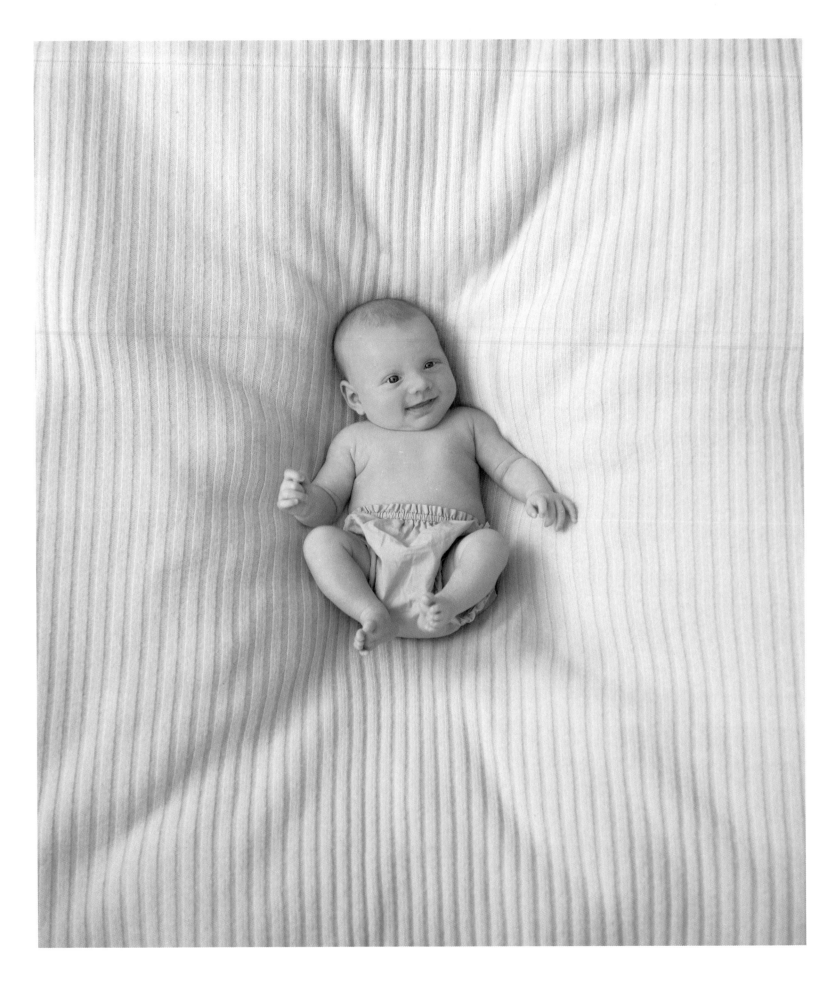

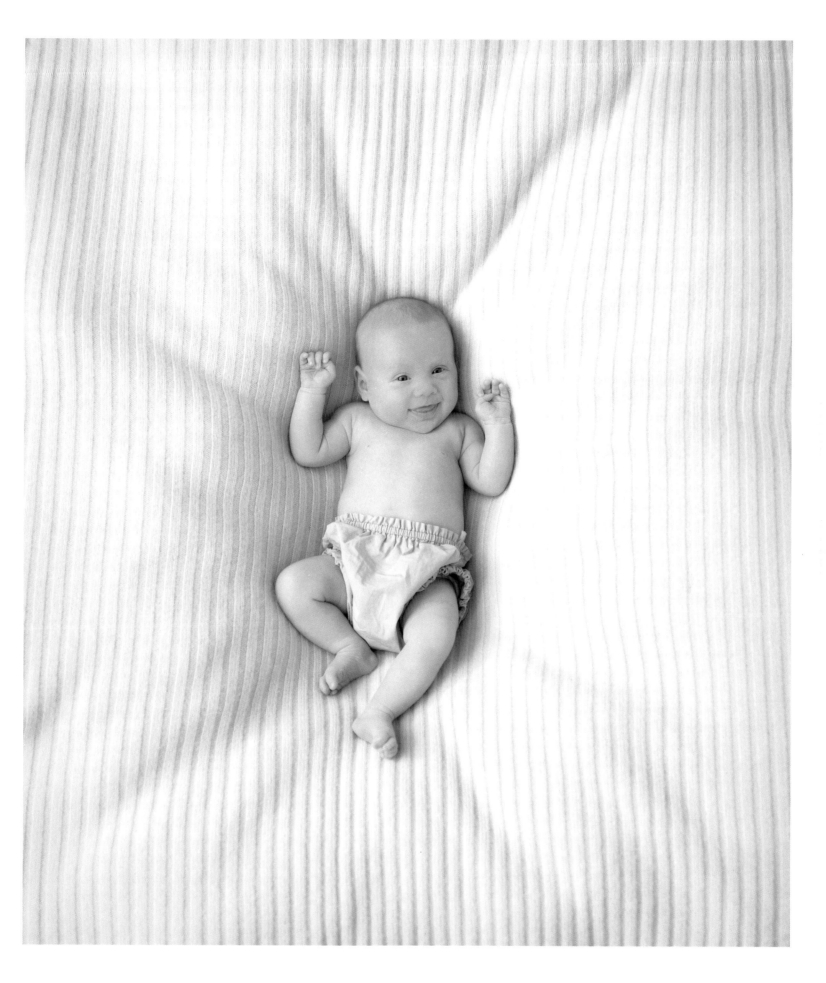

The Little Girl with a Curl

There was a little girl who had a little curl
Right in the middle of her forehead;
And when she was good, she was very, very good,
But when she was bad she was horrid.

HENRY WADSWORTH LONGFELLOW

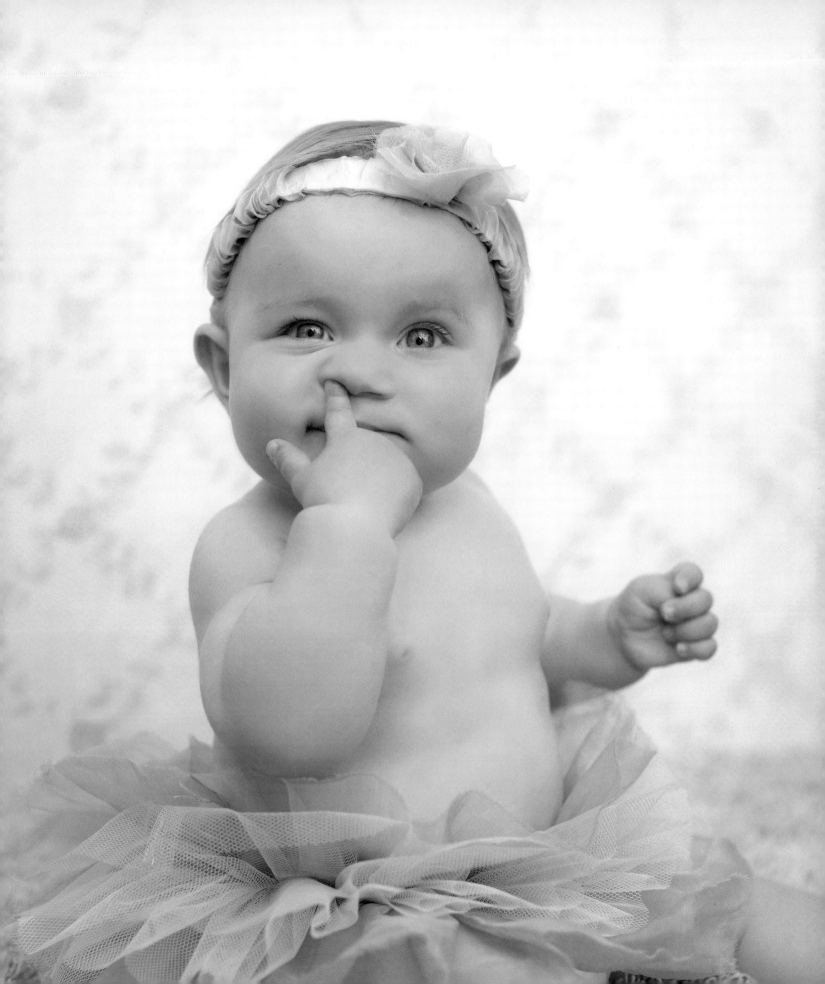

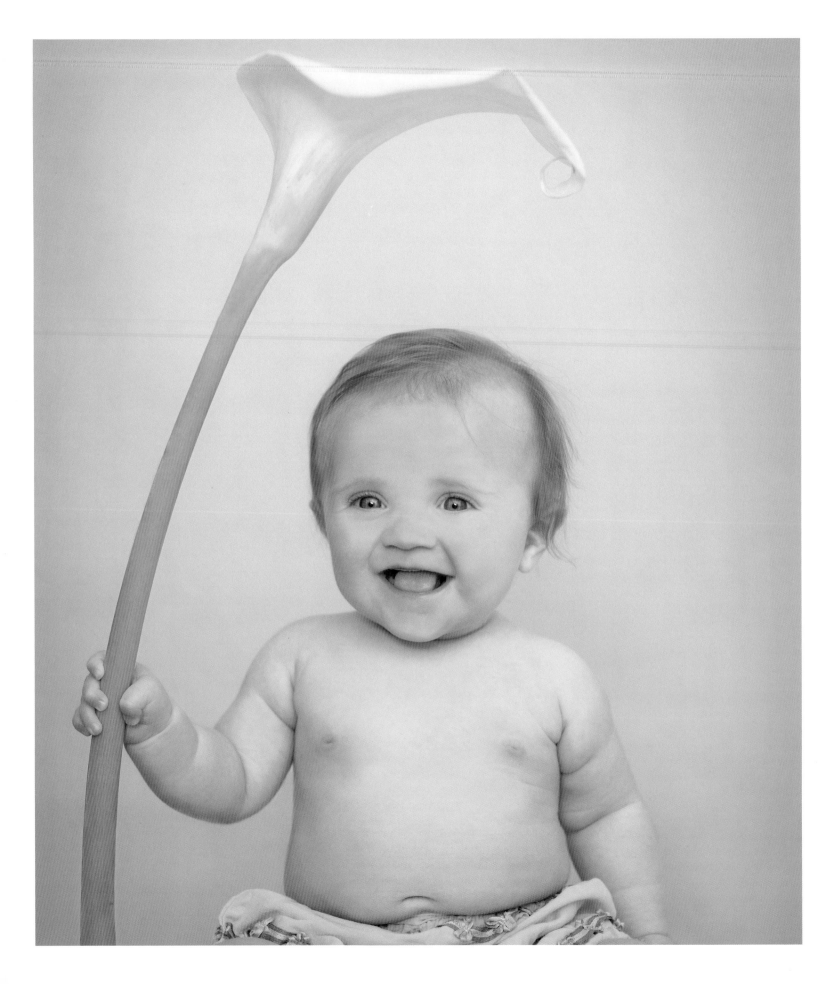

Birthday Celebrations

Around the World

ARGENTINA—When a girl turns fifteen in Argentina, she has a huge party and dances the waltz with her father and other boys.

CANADA—On the Atlantic side of Canada, the birthday child has his or her nose greased for good luck. The Scottish tradition says that a greased nose makes the child too slippery for bad luck to catch them.

CHINA—Birthday children in China receive a gift of money and are the guest of honor at a lunch party where noodles are served for good luck.

DENMARK—In Denmark, a flag is flown outside to show that someone who lives in the house is celebrating a birthday. Presents are placed around the child's bed where he or she is sleeping so they will be seen immediately upon awakening.

IRELAND—The birthday child is lifted upside down and "bumped" on the floor. One extra bump is given for good luck.

ENGLAND—Bumping is also traditional in England, but the child is merely lifted in the air rather than turned upside down. At the end, the "lifters" say, "One for luck, two for luck, and three for the old man's coconut!" The birthday child also receives an English fortune-telling cake complete with coins or other significant trinkets baked into the cake. Whatever the birthday child receives in his or her slice will predict the future.

GERMANY—There are several birthday celebrations that have become traditions throughout Germany. First, birthday candles are lit at sunrise and then left burning for the entire day. After dinner, everyone sings a birthday song and then the candles are finally blown out. Presents are then opened and a party begins.

INDIA—Children wear colorful clothes and hand out chocolates to classmates.

ITALY—School-age children have their ears pulled as many times as the age they are turning.

RUSSIA—In Russia, it is traditional to have a birthday pie rather than a cake. Often a child will have a special birthday message carved into the crust.

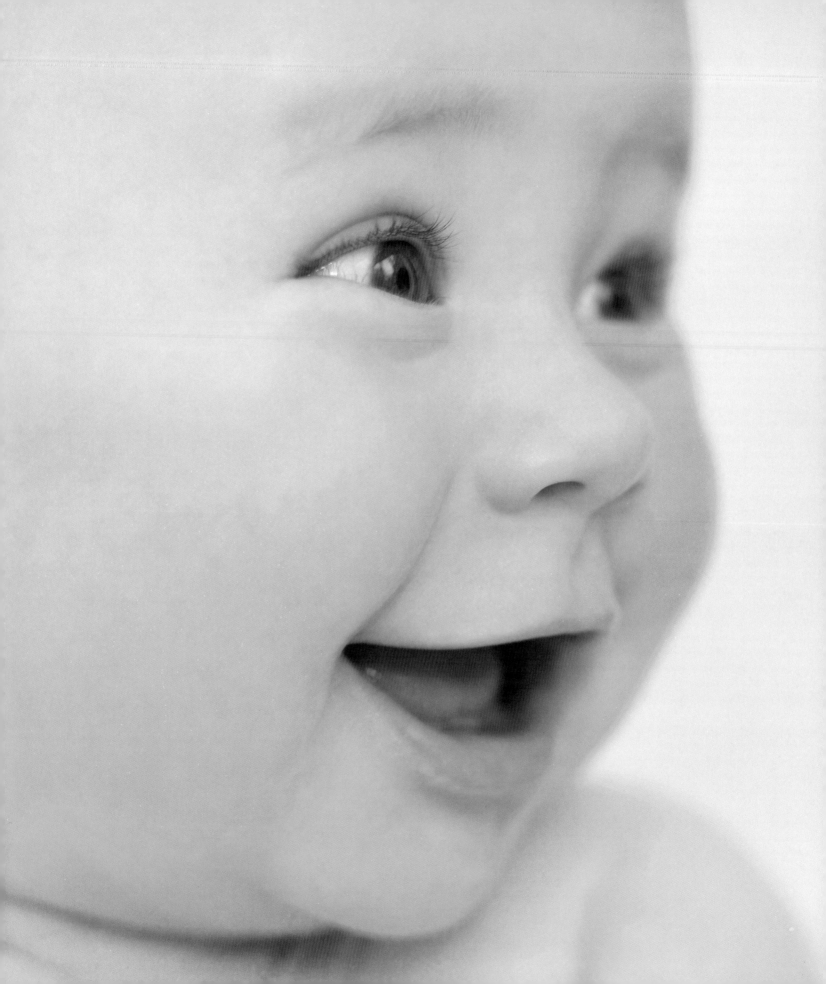

Baby expressions...

Babycakes: A term of affection between friends.
Baby + cake; to intimate a friend is "good enough to eat."

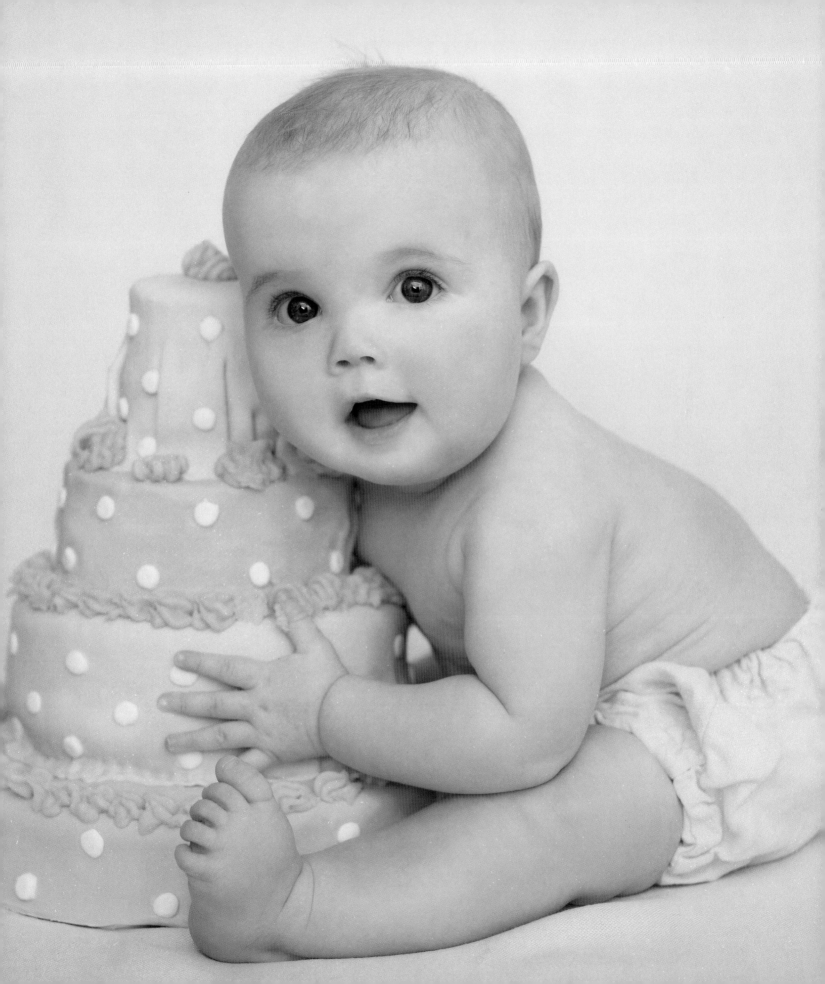

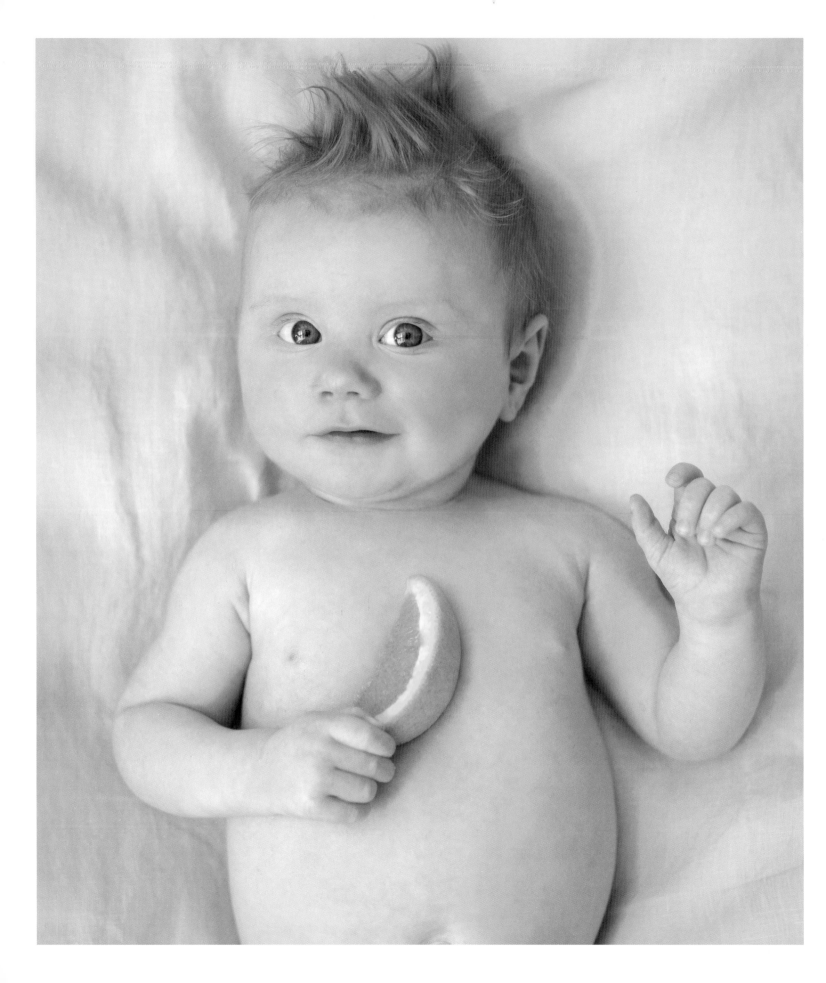

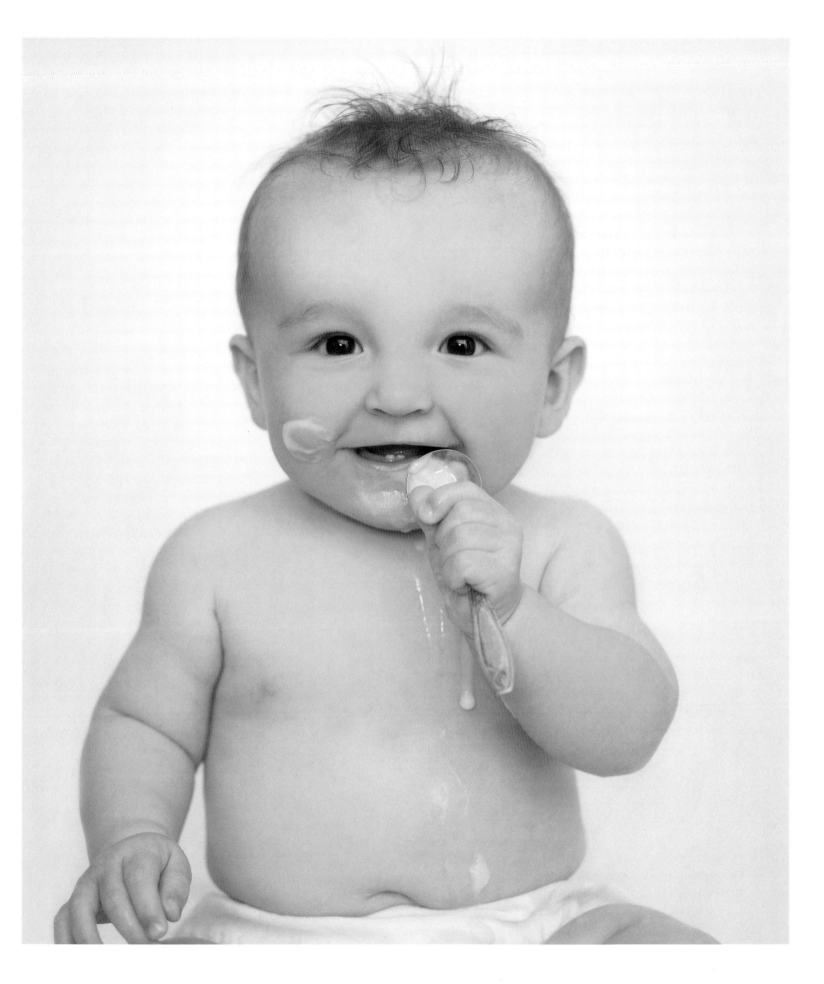

How to Fold a Pleat Diaper

1. Spread diaper out into a diamond shape.

2. Fold down top corner, stopping about an inch short of the bottom corner.

3. Turn the whole diaper over.

4. Take bottom corner up again, folding from a/b to make a pleat.

5. Fold diaper in half vertically.

6. Place baby on diaper. Bring middle part up between legs. Fold sides one over the other and secure.

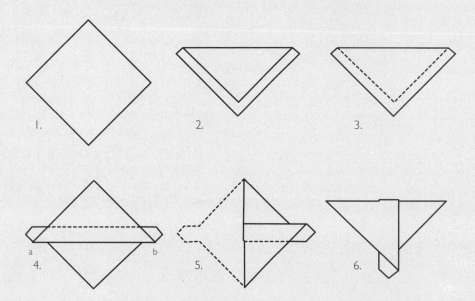

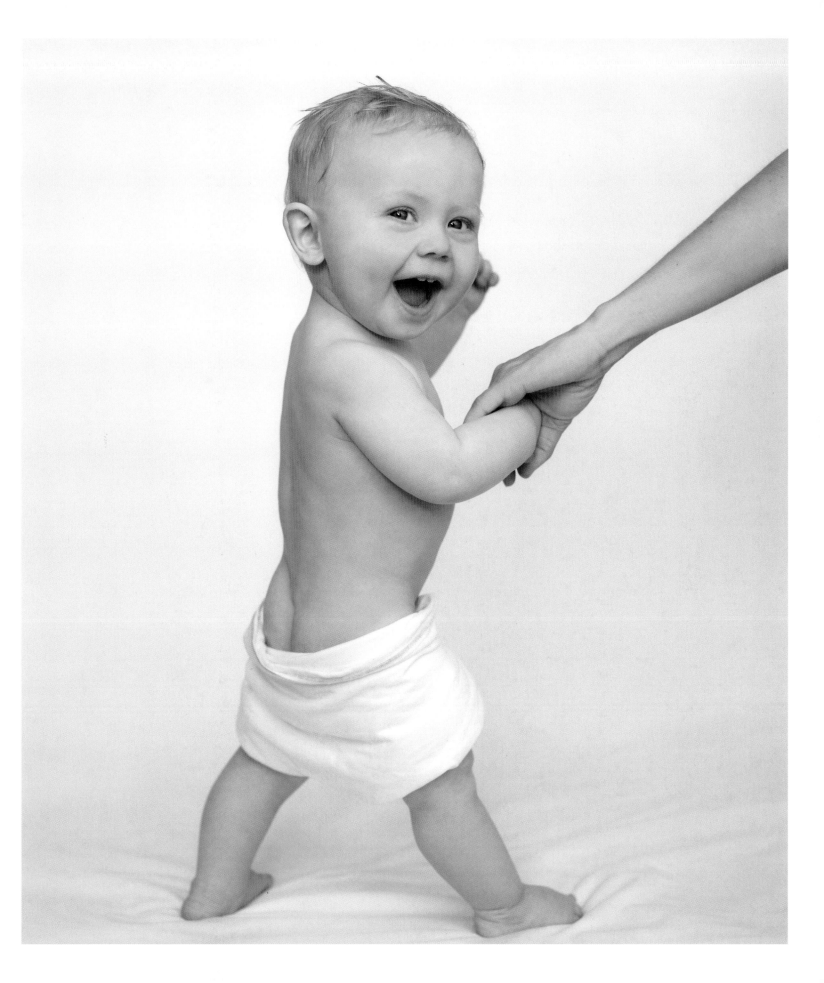

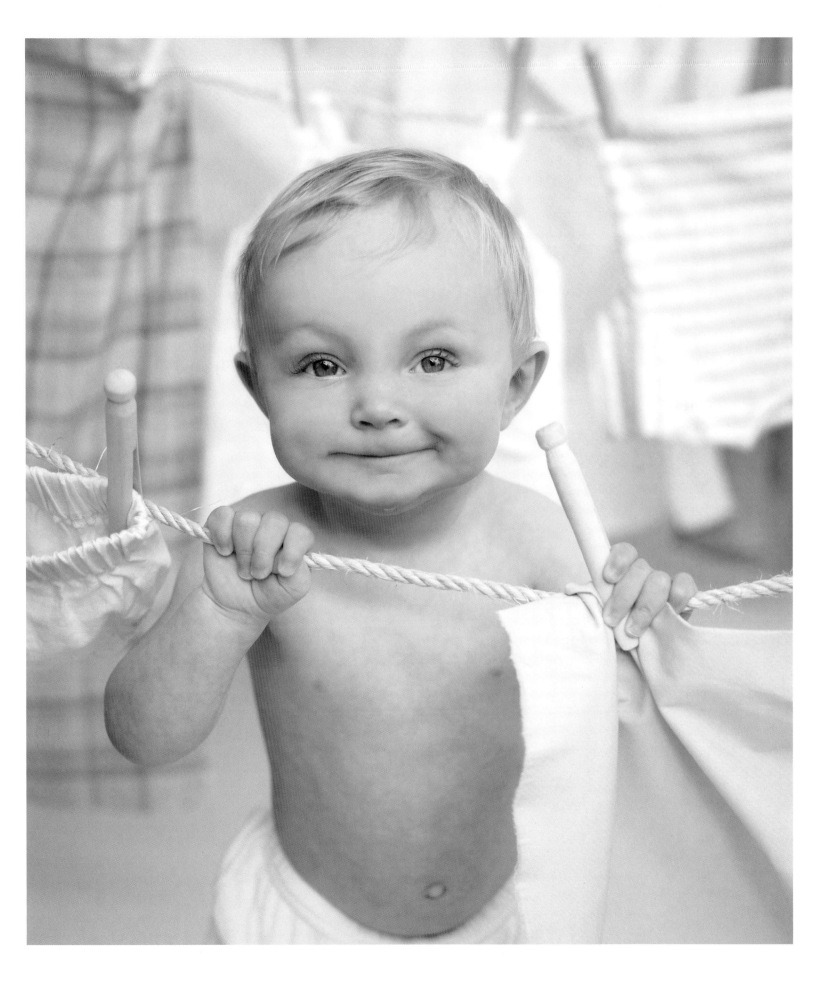

Baby Feet

Tell me, what is half so sweet

As a baby's tiny feet,

Pink and dainty as can be,

Like a coral from the sea?

Talk of jewels strung in rows,

Gaze upon those little toes,

Fairer than a diadem,

With the mother kissing them!

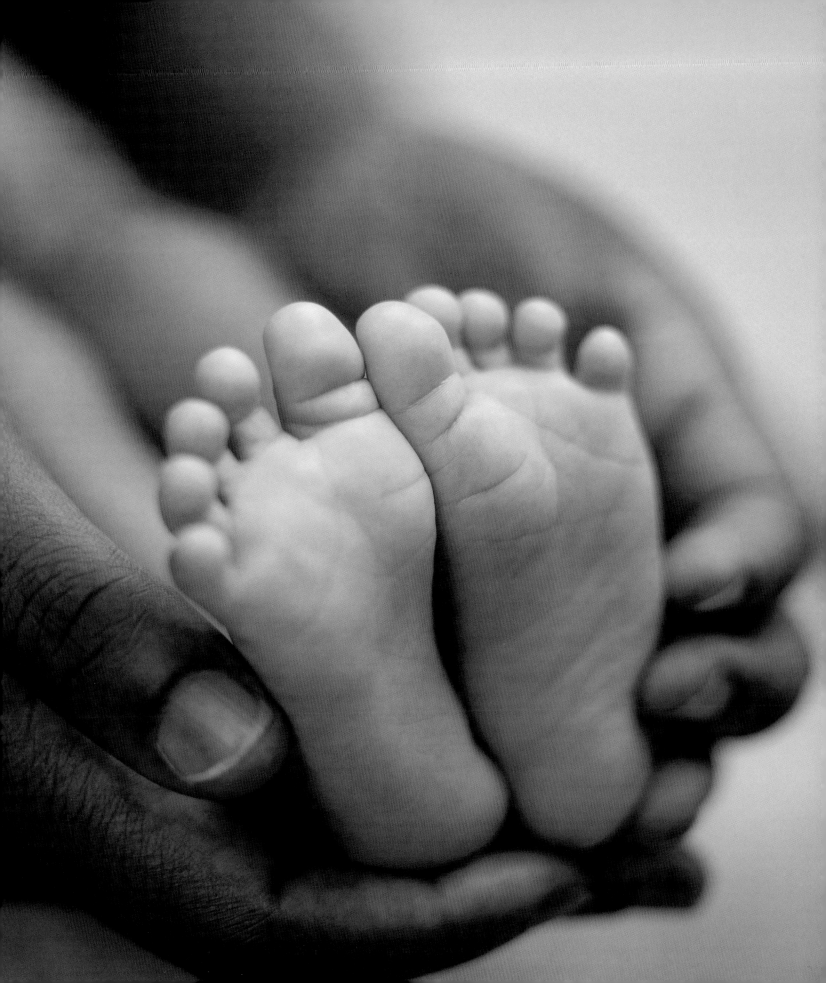

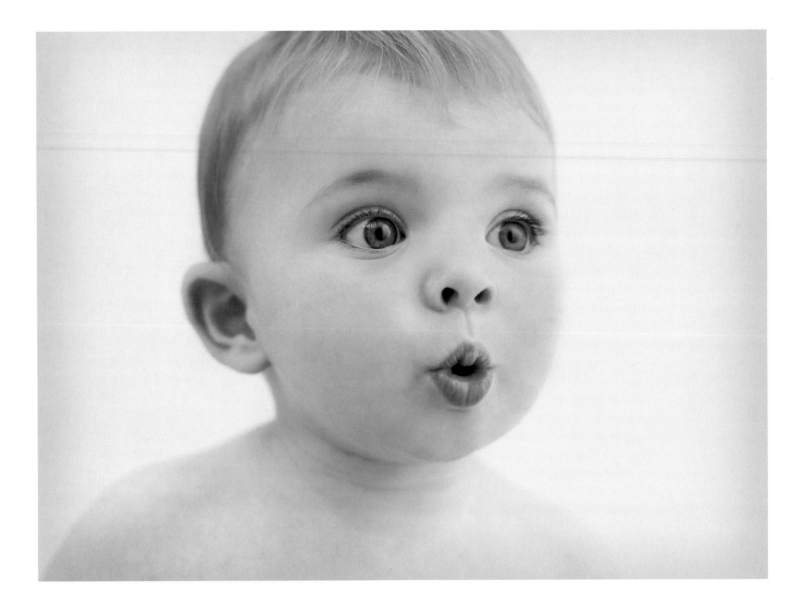

Little feet that do not know

Where the winding roadways go,

Little feet that never tire,

Feel the stones or trudge the mire,

Still too pink and still too small

To do anything but crawl,

Thinking all their wanderings fair,

Filled with wonders everywhere.

EDGAR GUEST

Not flesh of my flesh
Nor bone of my bone,
But still miraculously my own.
Never forget for a single minute,
You didn't grow under my heart,
But in it.

FLEUR CONKLING HEYLIGER

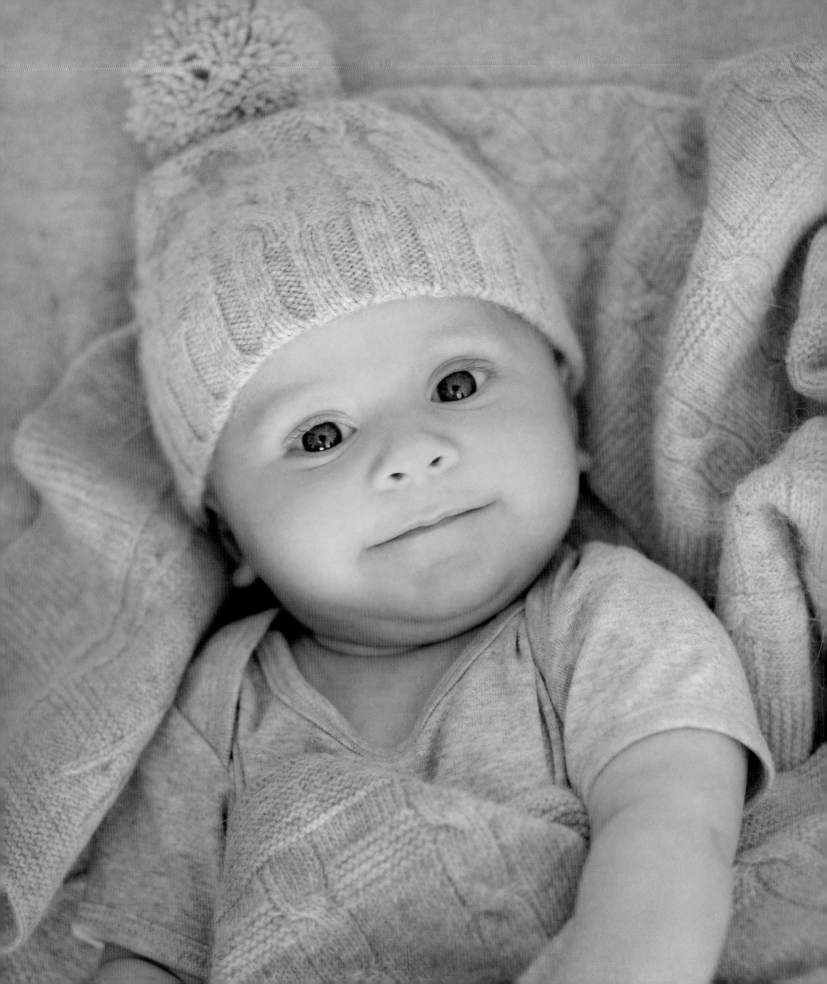

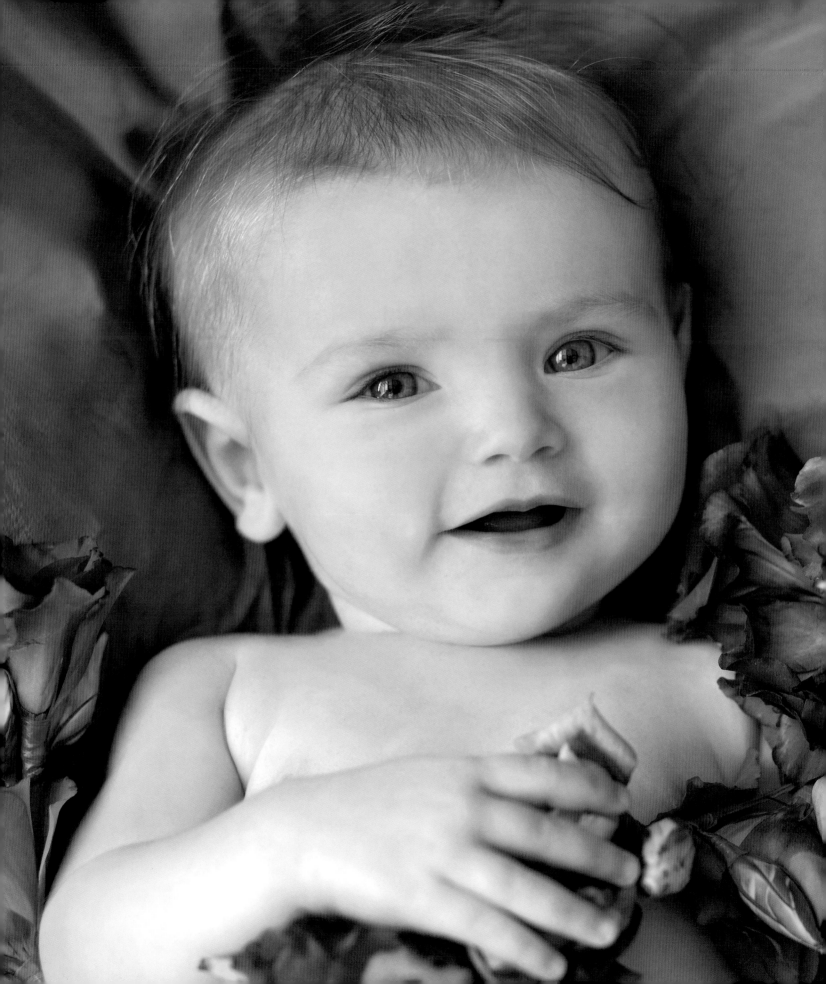

ACKNOWLEDGMENTS

As a longtime photographer of animals, photographing babies is a new and exciting direction for me. Ironic really, considering the oft-repeated advice: "Never photograph animals or children." People often ask which subject is easier—animals or babies? The truth is they are both just as complex, time-consuming, and incredibly rewarding. Although I've had to adapt my approach somewhat, my repertoire of noises to attract and distract puppies seems to work just as well with babies!

At first the thought of creating enough images to fill a book was honestly a little daunting. Although I've always loved babies, I've never had a child of my own. Thankfully my best friend, Jo, and her husband, Rawdon, have blessed this world with three adorable little treasures whom I have watched grow, and through whom I have witnessed the rewards babies and children can bring. Thank you, Jo, for your support and encouragement throughout this project; your honesty and emotion when viewing the photographs made me realise I was creating images that truly touched people.

There is an endless list of people who need to be thanked in relation to this book. Not everyone can be mentioned in person, but please know that I am very grateful to you all. *Baby Love* would not have been possible without the help of my faithful assistants Nathalie Giacomelli, Charlotte Anderson, and my good friend Rae Jarvis. Every image had at least one set of watchful eyes and hands continuously at the ready, just inches out of shot, ready to catch a wobbly sitter or to mop up yet more dribble! Thank you so much for your patience and tolerance.

Geoff Blackwell, thank you. Although this project has probably been the most challenging of my career so far, it has also been the most rewarding for me creatively. Your belief and enthusiasm is humbling. An enormous thanks also to Ruth Hobday and the rest of the team at PQ Blackwell—you make the journey through the production of a book so pleasant and enjoyable, I couldn't think of a nicer team of people to be involved with.

A HUGE thank-you to all the babies involved in the project, and to your parents for trusting me with their precious new family members and allowing you to be photographed. I am sorry to those who didn't make the final book; I hope you will remember the experience fondly when you revisit your images.

Another big thank-you to Birgitta Nilsson for your fantastic styling and prop making; to Susan Christensen and your team of florists at Orlando and Flowers on Franklin for the beautiful garlands; Global Fabrics—your fabrics are inspirational; the numerous midwives, especially Jan Smit, who introduced me to many of the babies I photographed; Nature Baby, Child, Bang Bang Café, and Chambers for passing on my details to some of the little characters that passed through your doors.

A final thanks goes to my family and friends—especially my parents, Bob and Barbara, who have taught me through their own love and care how to see the beauty in all children, and to my twin sister, Rebecca, who is always there to support me down whatever path I venture.

I hope the smiles and sheer delight on the faces of the babies in this book bring you as much joy as they have me.

BABIES' NAMES AND AGES

in order of appearance

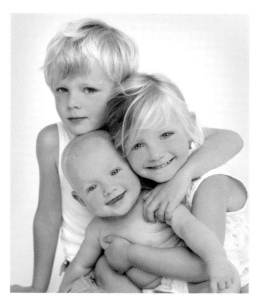

Dedication

For my adorable godson, Oliver, and his beautiful sisters, Georgina and Charlotte.
Your enthusiasm for life is contagious. I treasure every moment I spend with you.
Love always,
Rachael x

ISBN-13: 978-0-7407-7612-0
ISBN-10: 0-7407-7612-6
Library of Congress Control Number: 2008921095

Produced and originated by PQ Blackwell Limited,
116 Symonds Street, Auckland, New Zealand
www.pqblackwell.com

This edition published by Andrews McMeel Publishing, LLC,
1130 Walnut Street, Kansas City, Missouri 64106

Book design by Cameron Gibb
Printed by Everbest Printing Co. Ltd, China